Discovering Watercolour

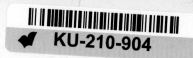

Discovering Watercolour

A Comprehensive Home Study Course

Jack Merriott VPRI ROI RSMA PS

Edited with additional exercises by Ernest Savage

Pitman Publishing, London

First published 1973 in Great Britain by Sir Isaac Pitman & Sons Ltd.,
39 Parker Street, Kingsway, London WC2B 5PB.

Reprinted as a paperback 1976

U.K. ISBN 0-273-01007-7

First printing, 1973

Text set in 11/12 pt. IBM Baskerville, printed by photolithography, and
bound in Great Britain at The Pitman Press, Bath.

6131:16

Foreword by Frank Sherwin RI

It gave me great pleasure to be asked to write a foreword to this instructional
book on watercolour painting. Anyone who met Jack Merriott could not fail
to notice his enormous enthusiasm. This is reflected in his course, which has
so ably been put into book form. I am familiar with every lesson and exercise,
as I was privileged to be a tutor on it for many years, and I can follow Jack
Merriott's sound reasoning behind every suggested brush stroke in the
exercises you are asked to do.

He enjoyed his painting and was at his happiest when out in the open with
one of his many sketching parties. You too will enjoy being with him on this
course, from which I know you will benefit. He was one of the best teachers
of watercolour painting of his time, and I have met many of his old students
who show in their work how much they have learned from his methods and
from his understanding of the pitfalls which beset the beginner.

I know that he would be the first to say that the road to success is not
easy and that it can only be achieved by hard work and observation from
Nature at first hand. You should continue to do the lessons and exercises
whenever you are able, right up to the end. After you have mastered the early
technical difficulties the clouds will lift and you will really begin to enjoy
your painting.

The student would do well to study carefully the colour reproductions and
skilful line drawings in this book. They are a joy to the eye and so much can
be learned from analysing them and the inspiration which prompted them.
I would refer you particularly to the lovely sketch "Porthleven" facing page 20,
from which we can all learn so much.

So start right away to learn all you can about painting in this fascinating
medium as set out in this excellent book by Jack Merriott.

Contents

Plates

Ernest Savage Introduces Jack Merriott

Though we had checked in only twenty minutes earlier at our *pensione* overlooking Venice's fabulous Piazza San Marco, our settling-in ritual was well under way. I had brewed the tea on the portable stove, while Jack Merriott was busily tidying up a pencil sketch he'd been making from the window, of the horses rearing exultantly above the entablature of the Basilica. This ritual had developed over many years of painting tours together. Although we invariably occupied a room's twin beds in the same relative position, our entrance into a new lodging would be the occasion for one or the other to demand the opposite bed. This peremptory challenge would be met by the other insisting on having the whole of the dressing-table top *and* the first drawer for his own personal use. We would then solemnly compromise, laying a tie across the top of the dressing-table, and have half each for our personal effects — the half agreed upon corresponding to our normal bed position. Innocents abroad, perhaps, but we had a lot of fun over such simple things.

On this occasion, the first of many visits we were to make to this enchanting city, we were stretched out on our rightful beds, sipping hot tea, an ordered array of sketching gear laid out in front of us. We were a little tired after an eventful train journey — our extrovert natures never permitted an uneventful one — but we were chatting away, recalling exciting painting subjects seen during our trip by *vaporetto* through the canals from the station.

Propped up on one elbow, Jack gave me a thoughtful but quizzical look, and — quite suddenly — said: "Ernest, old chap, when you write my biography, don't forget this moment!"

Jack's biography is still a treasured project for the future, but the publication of this book, which originated as a correspondence course for what was then the Pitman College of Art and Journalism, is my opportunity to recall and pay tribute to a great friend and a great painter.

Jack Merriott was a traditional painter of long standing and much experience. His free impressionistic style in oil, pastel, and particularly watercolour, is widely known. His pictures convey to the beholder, by subtle effects of light and atmosphere, a fine sense of tone, of delicate harmonious colouring and of sound draughtsmanship.

Born in London in 1901, he naturally gravitated to St. Martin's School of Art for his final training, though he started to earn a living as a shipping clerk in an office near London Bridge. During this period he spent all his leisure

time painting, and had several pictures exhibited in the Royal Academy. He was often caught sketching the shipping on the Thames during office hours on the backs of old invoices.

At twenty-eight, he decided to cut loose from routine work and to depend entirely on his talents as a professional painter. Important commissions were quick to come his way. He designed many posters depicting the landscape of Britain for British Railways, and for what was then the General Post Office. These exciting naturalistic posters, together with his frequent illustrations for the *Sphere* magazine, and many watercolours for a series of books called "Beautiful Britain," published by Blackie, brought him into prominence as a landscape painter.

He was elected a member of the Royal Institute of Painters in Watercolour in 1944, the Pastel Society in 1951, the Royal Society of Marine Artists in 1955, and the Royal Institute of Painters in Oil Colour in 1959. This imposing achievement shows what an accomplished all-round artist he was.

His work in connection with teaching painting was well known. He travelled around the Art Societies of Britain giving lecture demonstrations, and was one of the first in the field conducting private painting courses for progressive amateurs and professional painters. It was in this connection that I first met Jack Merriott in 1953. We seemed to take to one another immediately and by the following year he had persuaded me to help him organize a fast-developing programme of painting courses. From then on, until his untimely death in 1968, we remained close friends and partners, extending our painting enterprises throughout Britain and Western Europe.

The editing of this book has afforded me the opportunity to share with all those who were enthralled with Jack's painting my intimate knowledge of the man who gave such magic to the medium that he became known as the Wizard of Watercolour. The course was originally commissioned by Robert Light, of Pitman, as a comprehensive course of painting in watercolour for the ardent amateur to pursue in his own home. It achieved immediate success, and worldwide enrolments followed. The mass of tutorial work that developed entailed the recruitment of other teacher artists to assist, and Oliver Bedford, Frank Sherwin, R.I., and later myself, were brought in to cope with the assessment of pupils' work.

So warm was the reception for this course that all concerned thought that the infectious inspiration of Jack Merriott's teaching should be made available to a much wider audience, by means of this book. In it I have taken great care to retain as much as possible of Jack Merriott's original writing. The subject-matter, of course, has had to be rearranged for this new format, in order to achieve a greater continuity of lessons. It has also been necessary to redraft the practical work for the reader who would be working on his own, without the guidance of an artist-tutor. I venture to believe that the result provides an entirely new kind of teaching book on painting, for the enthusiastic student can profitably work through a sequence of studio exercises and

experiments, at his own pace, and thereby be confident of improving his technical know-how and his handling of watercolour.

Thanks to the complete and generous co-operation of Mrs Hilda Merriott, who gave me access to a lifetime's accumulation of her late husband's sketches and paintings, it has been possible to include a large selection of hitherto unpublished work. It indicates Jack Merriott's great love of Nature, and his conviction that to become an efficient landscape painter continual work from observation was of paramount importance. He was particularly prolific in his sketches, and the selection that illuminate the following pages are but a small fraction of his total output.

Jack Merriott was completely devoted to the pure watercolour tradition and looked upon the past masters with something akin to reverence. He tended to treat with scorn innovations in watercolour techniques, like over-use of body colour, of masking fluids, wax resistants, pastes and other texturizing materials, scratchings, combings and sprays, pad offset impressions and the use of coloured inks. These artificial aids, as he termed them, were unnecessary to anyone who had studiously worked hard to master the handling of pure watercolour.

His own watercolours will be remembered for their purity of colour, the apparent simplicity of their design and execution, and the evidence of sound draughtsmanship despite the impressionistic quality of light and atmosphere he contrived always to portray. It is toward the acquisition of these qualities that he directs his instruction in this book.

There will be many practising artists who will argue that the accepted technique of watercolour painting must change and advance with the use of new methods, materials and equipment. I go along with this, since the artist must always be free to make visual interpretations by whatever means he wishes to adopt. The trend away from pure watercolour is already well established in the fine works of many contemporary artists. However, I firmly believe that it is in the interest of the student watercolourist that he should become thoroughly acquainted with both the handling and the possibilities of the true watercolour pigment, before taking his studies to a greater depth into the realms of mixed media. It is in this sense that this manual can be invaluable to him.

The friends and pupils of Jack Merriott are legion. They will welcome this book, for in it they will hear the voice of this exuberant and sincere teacher, who wrote as he spoke. It will help those who are meeting him for the first time in these pages to understand that it was the beauty of the universe that inspired him. I am sure that they will be inspired to try and master this delightful medium and, as many have done in the past, will fall under his spell!

Ernest Savage

Fittleworth, Sussex, 1973.

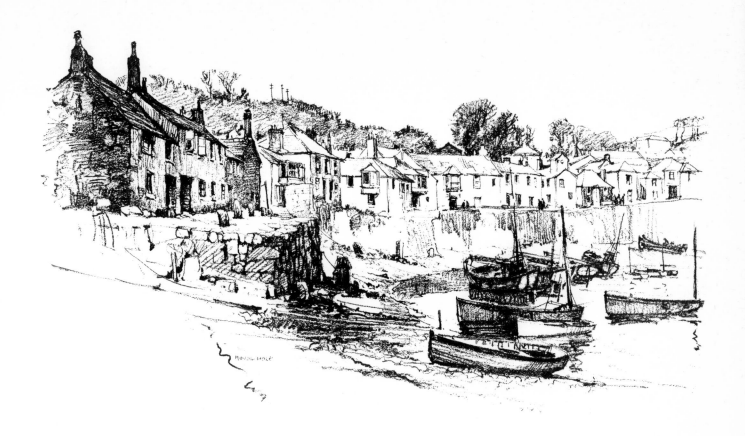

1 *Your Personal Approach to Watercolour*

APPRECIATION OF WATERCOLOUR PAINTING

To get the fullest possible enjoyment from your painting, you should develop a keen interest in the work of the great painters of the past and present and become acquainted with the many styles of painting in watercolour — broad, loose, tight, decorative, and the different approaches — abstract, surrealist, symbolic, imitative, impressionist, and so on. Each has its particular interest and, if only by virtue of contrast, we should be able to enjoy them all.

The different trends in watercolour painting, from the early watercolour school to the present day, may be studied during visits to the British Museum, the Victoria and Albert Museum, the Wallace Collection, and other British and American galleries, including the contemporary watercolour exhibitions. Good reproductions can also add to your knowledge, where visits to galleries are impossible.

It is purely a matter of choice which style of painting you favour. By looking at all the pictures you can you will gain knowledge of the capabilities of watercolour, increase your understanding of it generally and develop a keener appreciation and love of the medium, and a more intense desire to use it.

The first notable landscapes in watercolour produced in Europe of which we have any record were by Albrecht Dürer (1471–1528). For some time after him the medium was used only sporadically, and mainly for miniature work and illuminating manuscripts. In this it bore little relationship to watercolour as we know it today.

In the year 1585 Sir Walter Ralegh fitted out an expedition of seven ships with the intention of founding the first English Colony in North America under Sir Richard Grenville as General. Among the personnel was a man named John White, acting in the capacity of the expedition's draughtsman. It was his duty to record, by making drawings, the people, plant, animal and bird life, and the natural scenery of the North Carolina coast. The medium he used was watercolour, and twenty-three of these drawings were reproduced in Theodore de Bry's authoritative work, *America*, in 1590.

Examination of the original drawings has proved that they possess true merit and a sensitive quality; also the full range of colour was employed in clean washes. John White's work we can surely claim to be the origin of the English watercolour school. The introduction of monochrome under-painting, restrained colour and dominant blue were later phases.

Although it was not uncommon in the days before photography for draughtsmen of various nationalities to make such topographical drawings in watercolour during their adventurous travels, watercolour did not really become established as a tradition on the continent of Europe. In England the use of the medium continued quietly until the latter part of the eighteenth century, when it suddenly blossomed out with the work of many artists of distinction, whose pictures are now recognized as some of the gems of art bequeathed to us.

The art of watercolour painting was then identified as a distinct and separate school, and we can look back with pride upon the work of such men as Richard Wilson, J. M. W. Turner, John Constable, David Cox, John Sell Cotman, Thomas Girtin, Peter de Wint and many others, leaders of a great tradition, and a very English one.

I have always admired and revered the work of such men, besides the many outstanding names of later periods, such as Wilson Steer and John Singer Sargent, to mention only two. I love the liquid use of the medium and the emotions such work inspires, the ways in which various effects are obtained and ideas are stressed.

Watercolour has never been accorded the same degree of importance as oil painting, yet, to my mind, in many ways the beauties of watercolour surpass those of oils. Watercolour can be employed with equal effect in important pictorial designs, is capable of equal development and, I think, is more sensitive than oils, being particularly suitable for the expression of the evanescent atmospheric effects which are the glory of the British scene. Perhaps that is one of the reasons for its popular appeal in this country.

CHOOSING YOUR STYLE

After familiarizing ourselves with the work of the old watercolourists and those of the present day, we naturally form a preference for a particular style or idiom. It is not for us to imitate such work — rather should we learn by it and set our course along the road which attracts us, deviating where we think fit and, by bold experiment and research, making our personal contribution and carrying the tradition a stage further.

MY OWN APPROACH

The work which chiefly appealed to me was that which followed the lines of impressionism. I could hardly wait to explore that wonderful world of Constable, the airy dreams of Turner, and to enjoy the tranquillity to which Cotman invites. Having allied yourself with me on this Course, I assume you are already familiar with my work and understand my language, and that you are prepared to walk in my direction. But whichever style you favour, I am convinced that the groundwork which I am preparing for you is essential for your success.

The degree of progress you will make with your painting in watercolour will depend upon the amount of experimental work you put into the technical exercises, and the effort you make to get into Jack Merriott's mind. Painting is a thinking business, and an understanding of his thought processes, when stimulated to paint natural effects, can undoubtedly develop your own.

Swanage: *Pen sketch.*

INTERPRETATION OF VISUAL IMPRESSIONS

Why is it that we desire to paint? The desire is brought about by an idea, evolved in the mind from something seen, remembered or imagined, which creates in us emotion, generally of pleasure or a sense of well-being, which we ardently wish to express in order that we may be able to recall such emotions and pass them on to other people, in the same way that we exclaim to our companion on the beauty of a scene. Coloured photographs of scenes or objects can, by assisting the memory, help in a small way to recall emotions experienced earlier, but in the language of pictures we have a means of personal expression far more comprehensible than either the photograph or the spoken word. It is a language clarified by colour, in which we can draw attention to those thoughts which are worthy of special note, stress items of importance and subordinate or omit those things which have no part in the idea.

Painting a picture is not sitting down to copy some object or scene before us, for that involves little or no activity of the mind. When we are arrested by something seen or experienced and are moved to express it in paint, we should ask ourselves what it is that chiefly inspires us. Is it the light, colour, pattern, space, movement? What is the essence of the subject? Having decided, we can then proceed to talk in terms of paint, coming straight to the point. We choose words (colours and tones) which best express what we wish to say, and, with brevity, using an adjective or adverb here and there (extra weight of colour, tone or detail) to describe or stress a characteristic of particular interest. Thus we say just sufficient to create the atmosphere and direction of thought. The imagination of the beholder of the picture can then, with pleasure, complete the thought.

INTERPRETATION OF PHYSICAL AND MENTAL REACTIONS

By way of example, let us look at my colour reproduction of "Porthleven," Plate I, and I will try to analyse my physical and mental reactions at the time.

It was a lovely sunny morning in June when I decided to drive over to Porthleven in the car. Under the heat of the sun I felt stifled and lethargic in the close confines of my car seat, and on arrival at my destination I was delighted to step out into the open air by the harbour. By contrast, the freshness of the air was like wine. I felt exultant in the brilliant sunshine and cooled by the fresh sweet ozone. It was this sense of well-being that I wished to express at once. Had I instead been in a London park or an industrial town with the same atmospheric conditions and the same reactions, I should have set about my task in just the same way, although I must admit that this view was itself particularly conducive to such happy emotions.

I started immediately to express the cool clear air by painting in the blue-grey sky, light, open, remote. This was then stressed by the simple blue-greys

and purples of the intervening headland and buildings. If we could now compare my picture with the scene at that moment, I am sure we should see that the tint of my sky did not approach the depth of pure blue which nature provided. To try to imitate her colour here was not my way of expressing light. In fact, if I had felt I could better stress the light by painting my sky red, then red it would have been.

I was not specially interested in the details of cliff and buildings, except in so far as they served my purpose of explaining the cool atmosphere, and here and there where I drew attention to points of light which told of the hot sun shining overhead, glinting on the corner of a roof and on the quayside. Then, in contrast, I wished to tell of the full glare of the sunshine on the beach, relieved and accentuated by the forms of boats. The latter are not detailed portraits of boats. Had they been, they would have distracted attention to them, and failed in their function of stressing the light which I chose they should serve.

I might visit that same spot on another occasion, perhaps on a grey day or a cold wintry afternoon. The scene, still redolent of poetry, would excite my senses quite differently by, perhaps, the pattern of subtle greys, the wealth of detail in a boat, its rigging and fishing tackle, or maybe the proportions of a group of buildings. Whatever it might be, we must try to use the components of our pictures so that they contribute fully to the expression of that which we wish to say. I desired in my picture to tell of two simple truths, the hot sun and the cool air.

The enjoyment derived from a picture is not necessarily commensurate with the amount of detail it contains or the complicated nature of its message. On the contrary, a watercolour is usually the better for its simplicity.

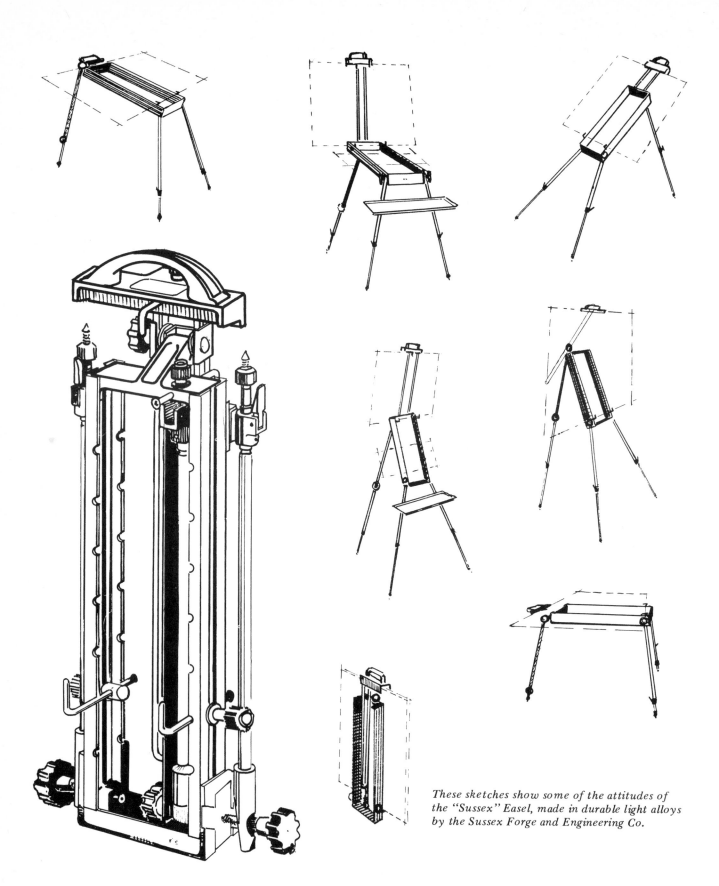

These sketches show some of the attitudes of the "Sussex" Easel, made in durable light alloys by the Sussex Forge and Engineering Co.

Fig. 1 Easel height. *It's important to have your painting surface within comfortable reach of your hand. To control liquid washes have the board fairly flat.*

2 *Materials and Equipment*

What pleasant thoughts are evoked at the mere mention of artists' materials. Shining new lead tubes with brightly coloured labels, the polished ferrules of new brushes, and the watercolour paintbox with its own individual smell. When I was a youngster, I felt positively idolatrous about such things, even to the extent of having an easel so placed in my bedroom-cum-studio that I could see its silhouette against the window when I awoke.

In equipping ourselves with materials necessary for our indoor and, more particularly, outdoor sketching activities, we must bear in mind the following points:

1. Economy in outlay consistent with good quality of essential items. It can be a very expensive business if you let it. A highly ornate box, gadgets, multiplicity of colours and instruments, although very intriguing, are detrimental to the best work. A good palette, good colours, and good brushes, are the main essentials.

2. In preparing your sketching bag for outdoor work, study the weight of the complete gear. Many times in my youth have I set out to spend a day sketching and, not having found my subject as quickly as usual, the result was a completely wasted and disappointing day. After trudging around for some

A water pot *made from a child's ball!*

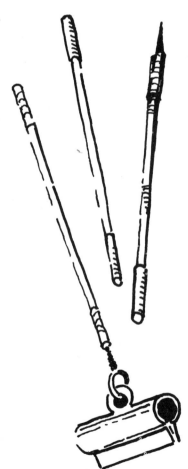

Pocket easel *shown in use above; it is in three parts with a clip below.*

time with a heavy kitbag, by the time I found my subject I was both physically and mentally tired out. If I had taken lighter gear, I should still have been able to tackle my subject with a fresh mind.

To work through the technical exercises and experiments in this watercolour course, you will need the following materials. Some of these you may already possess, and any additions can be made as required.

For sketching and drawing, layout and drafting

4 graphite pencils HB, 2B, 3B, 4B
A black conté pencil No. 2
A kneaded putty rubber (eraser)
Fibre-tipped pens, black and brown (Japanese Pentel)
Sticks of willow charcoal
Penholder and selection of Gillott drawing nibs
Indian ink, and sepia or brown waterproof ink
A foot rule
A sketchbook. I always use a 10 x 8 in. book bound with tear-off thin white bank paper (a thin smooth white paper)

Painting requirements

Drawing board, or sheets of hardboard, Masonite or plywood 16 x 12 in. and 16 x 23 in. With these you will need drawing pins (thumbtacks), clips, rubber bands, or Scotch or masking tape, to hold the paper to the board.
Plastic water bottle to hold at least a pint, and a water pot of light weight to hold a half pint
Small sponge and some absorbent rag

Portable wooden folding easel.

Easel

Serious painters will need a good sturdy sketching easel, capable of supporting the board firmly at any angle from vertical to horizontal positions. I have illustrated various easels for you, but the one I prefer is the French type. It is expensive but well worth it. I always use a portable easel to which I stand, and frequently use it in my studio to get just the angle I require for a particular task. I rarely use a stool. If, however, you are apt to get tired, erect your stool and easel so that your drawing is about knee-level, i.e. below the hand. (See Fig. 1.)

Brushes: *Round sable with fine point and flats for washes.*

Brushes

These are the most important items of your equipment. You may have poor colours or inferior paper and yet get the effect you want, but if your brush will not do what you want of it, then you are sunk. There is nothing more aggravating than a brush which splays out and refuses to form a point when you want it, or one in which, when it is drawn across the paper and lifted away, the hairs remain bent over and do not spring back into their original position. Good brushes are expensive, but they are worth having and should be carefully looked after.

After use, wash them out thoroughly with clean water, shake out and draw the hairs together into position with the lips before placing the brushes in a rack or on a sloping surface, hairs downwards, to dry out. If they are put into a glass or vase the damp settles in the roots of the hair and decays the ferrule. If put away in a box damp, the hairs will be damaged with mildew.

The best hair is, of course, the Kolinsky Red Sable. There are cheaper sables, mixtures, ox, squirrel, fitch, etc., and you must be governed by your pocket and preference. I think the ox is a very good substitute for the sable

and very much cheaper. One large flat brush for large washes, say 1 in. wide, is useful for skies, water, etc. (I find a shaving brush just the thing), and apart from this you need three or four sable brushes, a No. 14 or 12 if you can afford it, and Nos. 9, 4, and 2. These should all be well pointed. When the points are worn off, you will find they are still very useful when line work is not necessary. You will need one small hog-hair (bristle) brush with the bristles cut down to about ¼ in. for scrubbing out.

The natural manner of holding the brush is as you would hold a pen when writing, and I find that I paint small-detail work with the board close to me in this way. Apart from this, I usually paint with my arm extended, the hand in a similar position to the above, sometimes with the little finger used as a prop for steadying the hand when drawing; alternatively, for the broader work, the palm is inclined upwards and the thumb lightly clasps the brush to the index finger. I stand to work far more often that I sit.

The brush is an instrument sympathetic to every whim. It will hold a dripping load of sparkling colour, either strong or weak; it can be used when just damp with colour, or even with pigment which is almost dry. The variety of Nature is infinite and if we would attempt to translate her work to paper, we must try to employ every conceivable variety of means of expression at our command.

Jack Merriott's palette of watercolours

He invariably used the following watercolour pigments of artists quality in whole tubes. The colours used were:

Crimson (alizarin)	Cadmium yellow deep (or Hansa permanent
Cadmium red	yellow)
Light red	Viridian
Burnt sienna	Yellow ochre
Burnt umber	Ultramarine blue (French)
Ivory black	Monestial (phthalo) blue
Raw sienna	

On occasions, raw umber and sepia were used.

The colour box

The pigments were squeezed into the appropriate compartments of a black japanned colour box, topped up immediately before painting commenced, in order to have a good quantity of moist colour immediately available. For outdoor sketching, a De Wint palette box was used (Robertson) and for his studio work Jack Merriott chose the heavier Binning Monro box (Winsor & Newton) (Fig. 2). American readers could do no better than get one of the new lightweight palettes designed by John Pike.

Watercolour boxes fitted with pans

A watercolour box with deep mixing wells, containing the above colours in whole or half pans is quite suitable, so long as the pigment is in a moist state, and has not been allowed to dry out. The advantage of tube over pan colour is that the pigment is always very moist from a tube, and therefore more quickly converted into suitably toned washes. Speed with watercolour is sometimes essential.

The sketching bag

A satchel-type bag suitable for holding these materials, except easel and stool, is a must for outdoor work (Fig. 3). Art materials stores supply both quarter and half imperial bags, fitted with pockets and straps for materials and equipment. (The size of an imperial sheet is approximately 22 x 30 in.)

Fig. 2 Colour box. *This is an ideal type with compartments for pigment from tubes and large areas for mixing.*

Fig. 3 Sketching bag. *A useful kind to hold all your gear. It is made to take boards and paper in both quarter and half imperial sizes, with outside pockets for colour box, brushes, etc.*

Paper for watercolour

It is best to have several types of watercolour paper available. The weight of the paper to be used is important, and I prefer to use a heavier paper which does not cockle. Papers of 140 lb to the ream, or heavier than this, are best for direct work. Have several types of paper available for work to include — heavy drawing paper like Bockingford 140 lb (Barcham Green U.K.) and watercolour papers like Green's pasteless, Saunders or Arnold of 200 lb or more. Similar American papers can be found in the excellent range made by Strathmore Paper Company. And for a special treat, get a sheet or two of the French d'Arches or the Italian Fabriano.

A "not" (cold-pressed) surface to your papers is the best to use for a start. For your exercise work, buy full imperial sheets, and cut them into four.

I do not use thinner papers, i.e. lighter than 140 lb, for these really require stretching before use. I don't do this for my own work, as I feel that the paper loses some of its natural grain thereby. However, stretching is a common practice, and here is the procedure:

Soak a sheet of paper well in clean water, drain, and remove all surplus water by dabbing (not rubbing) with a clean cloth. Place the damp paper on your drawing board, and stick it firmly round the edge with brown adhesive-paper tape. Allow your paper to dry naturally, without heat.

The surface of papers

There are three surfaces made in watercolour papers — hot-pressed, rough and not (cold-pressed).

(*a*) Hot-pressed surface is suitable for drawing with both pencil and ink, and for the line and wash method. This surface is too smooth and slippery for pure watercolour work.

(*b*) The rough-surfaced paper has a definite tooth, holds the colour in the grain, and is susceptible to granulation, i.e. a somewhat speckled effect due to the fine particles of pigment being precipitated in the surface texture. This effect is sometimes desirable in parts of a picture, but is unpleasant and mannered if evident throughout. Rough-surfaced papers are very suitable for getting the dragged effect and sparkle (Fig. 8, *D, E, F*). This is done by drawing the brush, lightly charged with colour, quickly across the surface. The colour has no chance of sinking into the small crevices, leaving them white. This is a method suitable for effects of light on water, etc., and is appropriate for a bold loose style of painting with large brushes. It is not suitable for beginners.

(*c*) "Not" surface, merely means not hot-pressed. In America, a not surface is called cold-pressed. It is a semi-rough paper, suitable for dragged effects to a lesser degree, but more satisfactory for the larger washes of even texture such as for sunlit buildings. This is the best paper for your early studies. I still use this surface in the main, since it enables me to obtain both smooth and rough effects at will. It is also good for fine brush drawing.

De Wint paper. This is a coarser paper of a lovely grey tint. It has a beautiful texture, takes colour well, and is slightly absorbent. I do not recommend it for the beginner, as one is apt to feel that one's sketch is better than it really is because the paper itself is so beautiful. Also your range of tones is restricted, since the highest light is represented by the grey, compared with white if on white paper, and the colours and tones sink into the paper and dry out less dark than they appear when wet. It is suitable for pure watercolour or for line and wash, but is inclined to look dull compared with white paper.

Ingres and Michelet. These are slightly ribbed papers of light weight. They are excellent for line work in pencil or crayon, and also for watercolour in

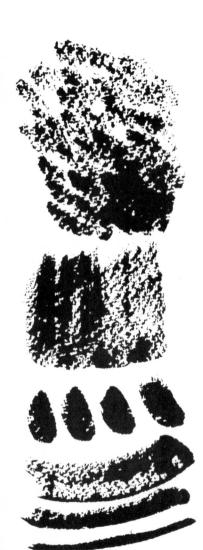

How a rough-textured paper influences watercolour wash.

the hands of the experienced watercolourist, but they will be found rather thin and apt to buckle.

Tinted papers. I do not advise the use of these. If you want a pervading tint, you can always apply a delicate wash to a white sheet and allow it to dry out. This has the advantage that you can wash down a portion to white paper again if you wish.

Watercolour boards. These are light watercolour papers mounted on cardboard. They are very nice to use but more expensive than paper, heavier to carry and to store, and are inclined to buckle with excess moisture in the wash.

Direct brush painting. The light on the trunks and fence is left.

This shows how to wipe out the lights, after the wash has dried.

For pure watercolour work I deplore the use of Chinese white. The beauty of pure watercolour as a medium rests in the delightful transparency of a limpid wash of colour on the white paper which is seen to glow through it. This is entirely destroyed by the use of body colour, which is opaque. Body colour and gouache have their particular attributes, but are outside the scope of *pure* watercolour. If you use white paper this should serve the purpose of your highest lights and such highlights should be very sparingly employed or they lose their value. Always keep a reserve of strength by you in the way of the brightest light and darkest dark.

When using De Wint paper you must very delicately tint all light passages or leave them entirely untouched, otherwise the tone added to the grey paper will effectively destroy the light.

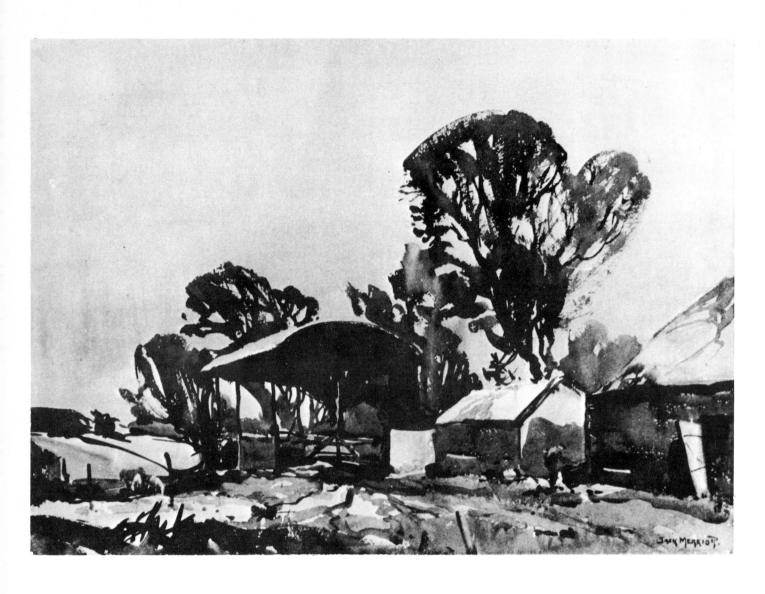

*Learn to draw with your brush as in this picture
of a farm in Sussex. Notice how the trees and
all the features in the buildings and fences have
been described with well-drawn tonal washes of
watercolour.*

Studio Workshop 1

BASIC TECHNIQUES FOR BEGINNERS

GETTING TO KNOW OUR MATERIALS

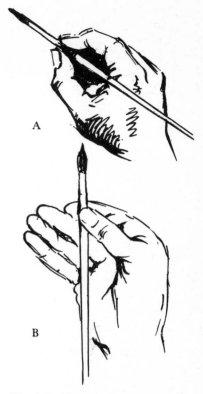

The first thing we must do is to get used to handling our materials. Take up the No. 9 brush and with it transfer about a teaspoonful of water to the palette in the paint box and mix some ultramarine blue into it; the depth of colour is immaterial. Take a sheet of drawing paper, fix it to your board. Now dip the brush into the blue wash so that it is fully charged without dripping.

1. I want you to paint various lines and shapes on the paper so that the colour will flow easily and evenly, to enable you to get the feel of the colour flowing from a fully charged brush, and see what it looks like when it is dry.

But how are you going to hold your brush? Just as you wish, but, to help you to acquire freedom of handling, I suggest you try out the two ways illustrated in Fig. 4, *A* and *B*. I use both methods. For detail work I would hold the brush as in Fig. 4*A*, and if special control is needed I extend the little finger on to the paper to steady the hand. For free washes, or vertical strokes, I hold the brush as in Fig. 4*B*. Whichever method I employ, I paint with the arm extended as much as possible, and without letting the palm of the hand come into contact with the paper.

2. With the No. 4 brush, draw a number of short, straight lines with the little finger extended.

3. A rapid scribble of three or four short broad strokes touching each other and painted with a flowing brush will produce a nice wet blot. If left to dry undisturbed it possesses one of the chief beauties of the watercolour, that lovely transparent quality showing the white paper beneath, which is sometimes called "bloom."

4. Find out all you can about the mixing of colours. To do this I suggest you set up your own chart by starting off at the top of a sheet of cartridge (drawing) paper with separate blobs of ultramarine blue, alizarin crimson and cadmium yellow deep. These are the three primary colours. In the next row mix the blue with the yellow, which will give you blobs of purple, orange and green, which are the secondary colours. After this, mix together your secondary colours in pairs to produce tertiary colours.

Fig. 4 *Hold the brush as above for detailed work; as below for broad washes and vertical strokes.*

Fig. 5 A scale of three tone values. *It's good practice to paint such a series of evenly washed values, in various colours.*

You should observe how these colours were all produced, make a note underneath each, and notice how the colours are affected by increasing the proportion of one constituent more than the other. This exercise can be carried further by introducing a little of any of the other colours in the palette, i.e. light red, burnt sienna or ivory black, making a note in each instance of every colour used.

TEST-YOURSELF EXERCISES

I have set the following exercises in order that you may learn to apply and control a wash, to get used to drawing with a brush and controlling its pressure, and also to familiarize yourself with the characteristics and mixture of the colours used. You may feel that there will be little to show in your exercises when they are done. But they are not by any means as easy as they appear. I hope you will not shrug them off as of little importance, for the fact is that the skills you can obtain by the mastery of these fundamental techniques are essential to good watercolour painting.

Make a workmanlike job of these exercises, using a quarter imperial sheet of drawing paper for each. Fill the sheet with your work, and where necessary in exercises compose your pictures and sketches to fill the whole area.

1. *Pigment in three tones*

Take a quarter imperial sheet of heavy drawing paper and fix it to your drawing board in an upright position; place your board on a table or easel at a slight angle, sloping towards you at a gradient of say 1 in 10. Have an absorbent rag or sponge at hand and fill a good big pot with water. Now take your HB pencil and, without a ruler, draw freehand, without taking the pencil off the paper, three rectangles roughly 2 x 1¾ in., close together like those in Fig. 5. Don't worry if your lines are not straight or the shapes not exact.

Drop into the well of your palette about a teaspoonful of water and with the No. 4 brush mix some ultramarine to a pale wash, about the depth of the illustration. When it is thoroughly mixed and no particles of pigment are left in the brush, apply this in strokes from left to right in the first rectangle, working from top to bottom as quickly as possible, but without hurry, and keeping carefully to the pencil lines. Your aim should be to produce a clean wash of even depth throughout. For the next rectangle, mix more pigment into the wash to a medium depth and proceed as before. Finally, mix still more pigment into the same wash to a dark blue and again fill in the third area evenly. You will find that the deeper the wash, the more difficult it is to keep it even throughout.

Repeat this exercise using cadmium yellow deep and alizarin crimson.

2. *Painting a gradation*

On similar paper draw three rectangles about 8 x 4 in. Take your No. 9 brush, put a little water into the second well of your box and again mix a pale blue. Apply this in the same way as before to the top of the rectangle. After two or three strokes add some more pigment to the wash and carry right on, adding more and more pigment as you go until you reach the bottom of the rectangle, which should be deep blue; the whole effect is a graduated tone from light to dark as in Fig. 6. Carefully lift with a damp brush any puddle of colour along the baseline, otherwise this will cause an ugly stain.

Repeat this exercise using cadmium yellow deep and alizarin crimson.

3. *A scale of tone values in colour, then matched*

The next exercise is to place blobs of colour of different strengths from a fully charged No. 9 brush (or No. 12 if you have one). This is done by holding the brush as in Fig. 4A, laying the hairs of the brush at full length on the paper, pressing and then lifting away (Fig. 8B). The resulting blob will be thin and transparent at the top, getting darker as the colour drains down to the heavy drop at the bottom. I have shown some specimens in black of different depths, and I suggest that you make many of these of varying shades and colours before tackling the exercise. Leave the blobs to dry and note what happens in the drying-out process. Are there any ugly granulated edges in the drop of some of the specimens? How did you produce your best examples? Can you repeat them?

I would like you to paint six rows of colour blobs as above on a sheet of paper, using six different colours of your own choice, each row consisting of five blobs well spaced as in Fig 7A, gradated from weak to strong colour, by adding more pigment to the original wash. When you have finished these thirty blobs, go back and try to match as nearly as possible each blob with a similar blob of equal intensity and purity (Fig. 7B). You will bear in mind what you have learned from Studio Workshop Exercise 3, that colour dries slightly lighter than it appears when wet. This is a very important fact to be learned; lack of attention to it results in weak sketches. By continually trying out these various tone values you will gain courage in the use of strong colours, and will learn to recognize them when seen as a puddle in the palette, and you will have a fair idea what they will look like when dropped on a sheet of white paper.

4. *Brush control practice*

Take the No. 2 brush and with pale blue draw a number of lines of fairly even width (using a full brush) (Fig. 8A). Then draw lines commencing with the brush point and gradually pressing on the brush until you get the full width, then lessening the pressure down to the fine point again, repeating several times to produce a line of varying thickness (Fig. 8G).

Fig. 6 Painting a gradation. *Learn to paint a gradually changing tonal wash from pale to deep by gradually changing tonal wash.*

Fig. 7 Blobs in changing tone. *Having created a graded series of colour blobs paint a tonally matching set. Learn to anticipate how a colour seen wet in the palette will look dry on the paper.*

Fig. 8 Brush control (right). (*A*) *With full brush test your brush control by painting a series of straight then wavy lines.*

(*B*) *Paint blobs in pattern, pressing the brush to the paper and lifting it.*

(*C*) *Watch the effect obtained when painting broad strokes as the wash in the brush gives out, leaving a speckled effect in the grain of the paper.*

(*D*) *Practise this dragged brush effect with an almost dry brush.*

(*E*) *Cultivate the habit sometimes of using the side of the brush, here shown to describe a tree with a fully charged brush. Then as in the next examples with dragged stroke for foliage.*

(*F*) *Experiment with a combination of dry and full brush painting, thinking of the eddying of waves or of footsteps in the sand dunes.*

(*G*) *Try varying the pressure placed on the brush, here making a wavy line by change of pressure.*

A B

A

B

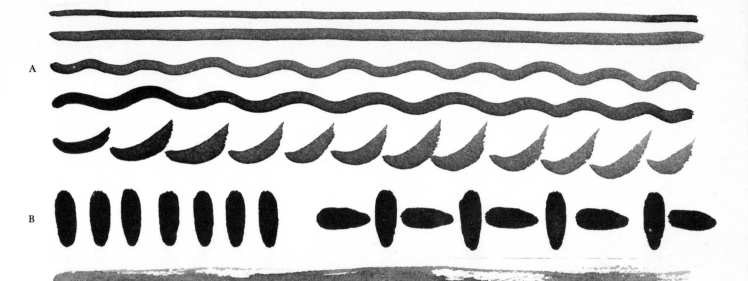

C

D

E

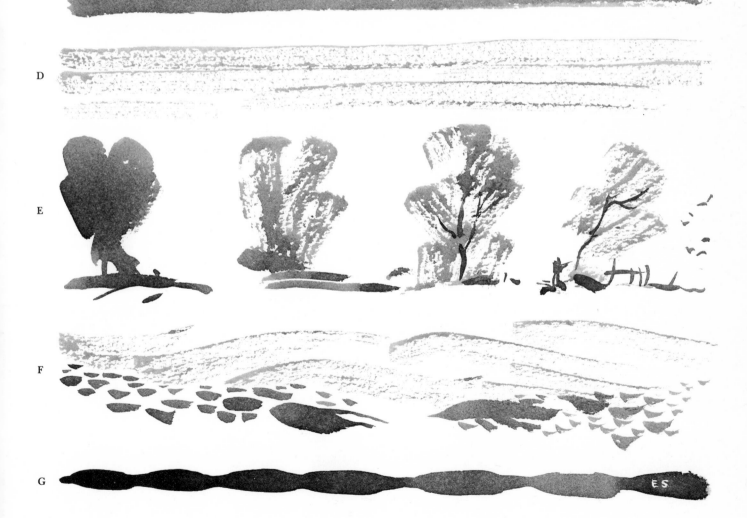

F

G

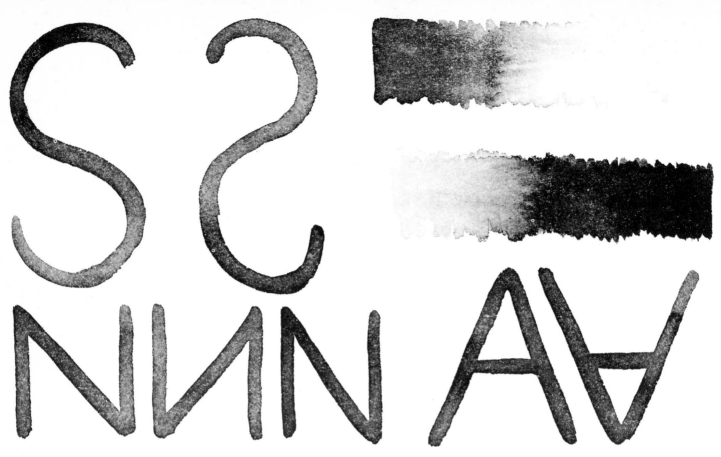

Fig. 9 Pattern Motifs *painted freely help to improve your handling of the brush for drawing.*

Fig. 10 (above) Gradations *help you to understand the characteristics of watercolour.*

5. *Brush-drawn pattern motifs*

With the point of a No. 4 brush and without lifting it from the paper, draw figures employing straight and curved lines, such as letters S and Z (Fig. 9). This should be done without resting the hand on the paper. Now invent some pattern motifs of your own.

6. *Gradating a colour, strong to weak, and reverse*

With the No. 4 brush charged with deep ultramarine blue paint a short down-stroke and then, by weakening the wash gradually on the right-hand side, reduce the depth to white paper (Fig. 10). Do it again with red and yellow. Next start with water and gradually add colour to the right to end in a line of full strength. While working, watch carefully what takes place, e.g. how the ultramarine blue is inclined to granulate and how vicious is the action of alizarin crimson when introduced to water and, when a strong wash is allowed to touch a pale one, how rapidly the latter is entirely suffused.

By watching and remembering these effects we build up our experience and can make use of them or carefully avoid them as necessary.

PORTHLEVEN
Watercolour 15 × 21 in.

The artist's physical and mental reactions are aroused when viewing this Cornish harbour. The strong sunshine coming towards the artist gives tonal strength to the headland and boats seen against the light. Sharp accents of light have been skilfully left to describe the glint on roofs and quayside. About three washes from light to dark sufficed for this picture.

Plate I

SNOWBOUND CHICKEN RUN
Line and wash 15 × 22 in.

This exciting method, using Indian ink with a brush followed by the embellishment of a quick wash of colour, is described in Chapter 3.

Plate II

3 *Graphic Expression*

If you have persevered with these exercises you should by now have gained some experience in the preparation and application of a simple wash, the control of depth of both tone value and tint, ability to gradate, freehand control of brush and pencil, and elementary colour mixing.

These are the foundations of technique. We will proceed to make use of this experience by carrying our studies a stage further, to include drawing and graphic expression.

There is a school of thought today which contends that, in order to paint, it is not essential that you be able to draw. As mentioned earlier, there are many styles of painting and so far as some of these are concerned I do not contest the point. It is not necessary that you be able to draw if you wish to paint without that accomplishment, but I do maintain that an ability to draw will help you to paint better. It all depends on how you see and feel about the things around you and how you wish to express them.

Some painters, like Cézanne, for example, see Nature as a pattern of colour masses, each colour being carefully related to the next. It is a language in which are expressed the emotions of excitement, tranquility, sorrow, joy, and many others, by colour combinations, harmonies, sudden contrasts, and so on.

The colour and pattern becomes the essence of the style and good drawing is not necessarily required. There are other styles, too, where good drawing is not essential. However, I still consider that, whatever the style, good drawing can only be beneficial rather than otherwise, and for my own particular style it is essential.

Drawing is commonly understood to mean the delineation of an object or scene in line and shading. This is not my conception of its true meaning. I would prefer to say that it is the expression of form by means of tones and shapes. Line need not be used at all; on the other hand, form can be expressed by line alone, as evidenced in some of the work of Holbein.

There is no outline to objects in Nature. An artist uses a pencil or pen line or patch of colour in order to identify one form from another or one form from space, so that, unless the line forms an actual part of the pattern, it must belong either to the object or to space. It cannot belong to both.

In this course I shall be dealing with three different methods of watercolour painting, one of which depends entirely on line and shading; the other two seek to dispense with line entirely, or as much as possible. Whichever we choose, we still need to cultivate a full appreciation of form and the power to express it, which is *drawing*.

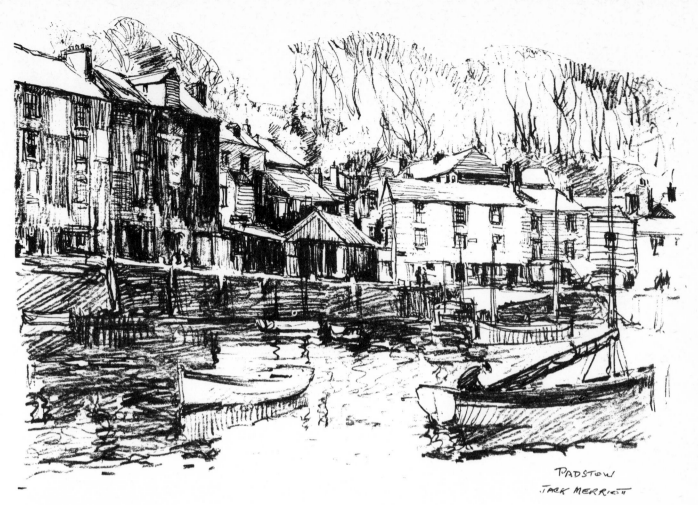

Padstow *(above), with soft
pencil;* Widecombe *(left), with
fibre-tipped pen.*

THE IMPORTANCE OF OBSERVATION

Try drawing any object which is on the table or desk before you — your ink-
well, ashtray, book, cup and saucer. First take the object in your hand, run
your fingers over it to get a full appreciation of its form, surface texture and
weight. Then place it before you and look at it as a silhouette. You will
probably start by drawing the outline. If you do, regard your line as merely a
boundary to help you to get the shapes of the different tone masses correct.
Providing the latter purpose is served, eliminate the outline as much as
possible and concentrate your attention upon tone values. By this I mean the
tonal relationship between background and object, object and shadow. Then
in the object itself observe the difference in value between highlight, light,
shade (which contains reflected light), and that portion where light merges
into shade. This change of tone is usually the most important since its
correct expression will explain the form.

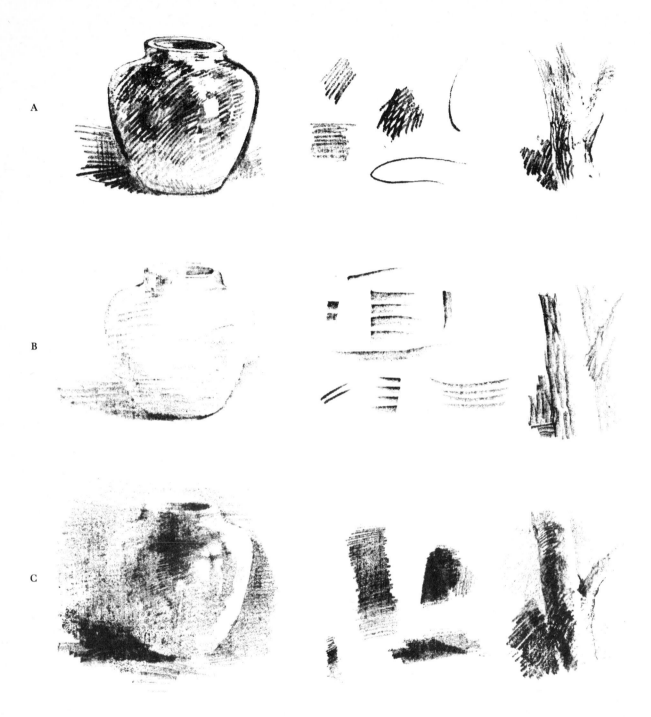

Fig. 11 *(A)* Open line drawing *with graphite pencil.*
 (B) Lose the outline *by describing the background.*
 (C) Massed shading *with graphite pencil.*

A jar in open line drawing

I placed before me a simple glazed pot and took up a cartridge (drawing) paper pad. With the HB pencil I drew it in outline lightly and then went over the lines with the 2B pencil, varying the thickness of the line to suggest form, then getting my tonal variations on pot and background by means of hatching and cross-hatching (Fig. 11*A*). I show alongside the pot the method of hatching used and you will see that the form is suggested entirely by open lines of varying depth and thickness and distance apart, and also that the lines are inclined to follow the direction of surface. Note here how on the left-hand side (the shaded side) the outline belongs to the pot, whereas on the right-hand side (the lit side), the outline belongs to the background.

Losing the outline

Figure 11*B* shows the same pot expressed with as little outline as possible, surface forms being explained by thick lines which follow the direction of the surface, drawn with the 2B pencil held with the side of the lead in contact with the paper. These lines commence with full pressure on the left of the pot and pressure is eased gradually as the line is drawn to the right, thus varying the tone to light. Specimens of the pencil strokes enlarged are again shown alongside.

A jar in mass shading

Figure 11*C* is the same pot again, expressed without outline, the pencil being used merely to obtain tone masses similar to those which one gets with a brush. Tone is secured by scrubbing the pencil back and forth, producing lines close together, and varying the pressure on the lead according to the depth of tone desired.

Here then, are three different ways of suggesting form; lines and tonal mass are the means — a full appreciation of form is the end. That is *drawing*.

I do advise you to do all you can to master the art of drawing objects in line and tone with pencil and brush, accurately and truthfully. You will learn later what a tremendous help it is. When one can do this, one can dispense with the technique of line and dwell only on considerations of tone and form. If you can draw accurately, then masses of tone and colour will be painted in the right shape, and if they are distorted it is because you want them to be, not because of your inability to do otherwise. However much you appear to lose your drawing, the power of it is always evident below the surface. Look at some of Turner's great works in his later period, in both watercolours and oils. What atmosphere and light! No line here, but what consummate power of draughtsmanship is evident throughout!

There were three methods of approach with watercolour painting which Jack Merriott adopted for his personal work. These were:
1. *Line and wash*
2. *The direct method*
3. *The controlled wash method*
Each is capable of extensive development, and can be employed individually or merged together. We consider line and wash right now. The other two methods are dealt with in the next chapter.

LINE AND WASH

The line and wash method is the natural development from experience in line drawing. For those of you who are a little less courageous in the use of water-colour and feel that you cannot yet safely do without a clearly defined line, as well as for those who wish to loosen up an already tight manner of painting, line and wash should be of considerable assistance. I do not consider the method to be pure watercolour, but that is merely a matter of nomenclature; the fact is that a great deal of this sort of work has featured very much in the important exhibitions of recent years.

"Snowbound Chicken Run" (Plate II) is an example of this method.

The essence of my method is that the composition is first and foremost a line drawing, the line being of paramount importance. It should be a complete drawing, with all details which we wish to emphasize carefully indicated (with the exception of the more subtle and atmospheric effects of light, clouds, etc.), including truthful tone values and delineation of texture, i.e. surface character of the objects portrayed. When toning an area in shade or half-tone, open hatching lines should be employed (Fig. 11A), thus leaving areas between these lines to take a tint.

The lines should follow a direction best calculated to describe the structure or surface of the object. Lines should have light and shade in themselves in that they can be as thin as a hair or as thick as cord. Though it is possible to do this line work in Indian ink with a flexible drawing nib, undoubtedly the best results are obtained by using a finely pointed brush, Nos. 2, 4 or 9, for

the ink work. My whole idea, in this method, is to get the full tonal rendering of the picture with ink and *not* with the colour.

Of course, the line work can be done with soft graphite pencil, or even a charcoal pencil, though normally I use Indian ink.

When the line work is finished, and the ink is dry, a watercolour wash is applied all over the picture, changing in tint according to the local colour of the various parts of the composition. Each colour should merge to a great extent into the adjoining one; thus no real attempt is made to paint individual components of the landscape.

The whole composition is held together by the line drawing, not by the colour. Hence the colouring of a line and wash drawing takes only minutes to do; the line work, on the other hand, could take hours.

This method is chiefly suitable for architectural subjects, and those that require a special graphic treatment.

Other line and wash methods

The technique described above was Jack Merriott's own interpretation of what really constituted a line and wash drawing. He deplored the use of this term for an ink line drawing, without ink tonal work, subsequently coloured with wash.

"This is not a line and wash," he would say when examining a pupil's work done in an outline method. "This is a tinted drawing."

However, it is of some importance to the student to realize the variety of ways in which waterproof ink work can be used with watercolour. Artists have a way of being individual, creating methods to suit the visual impressions they decide to make. Thus some prefer to minimize the amount of line work, seeking to establish tone values with watercolour, while others will start with a freely painted watercolour composition, and finish with some broadly drawn ink lines, to pull the design together, and to give emphasis to a particular part of it.

The extent to which ink line is used in a painting is a matter of the individual artist's requirements and of how he wishes to express himself in the particular picture he is engaged upon.

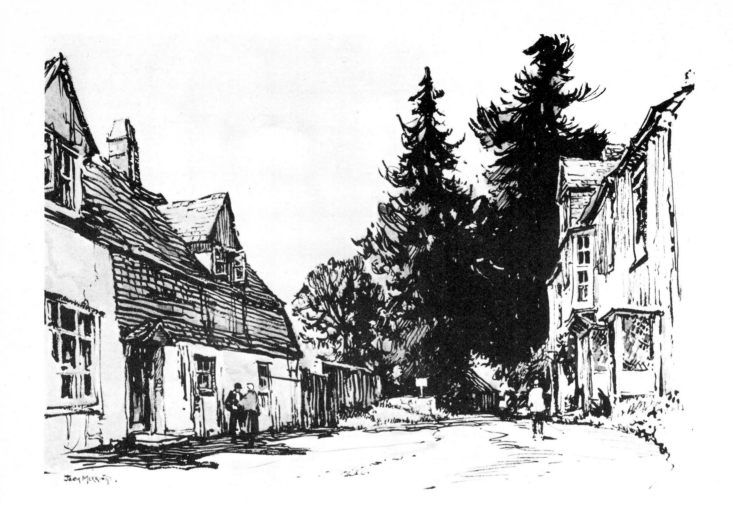

Fig. 12 Line and wash technique. *The essence of this method is that the composition is first and foremost a line drawing. In this drawing in Indian ink and brush the line describes all the details needing emphasis, the delineation of texture including a truthful portrayal of tone values. The watercolour wash is merely an embellishment applied all over the picture, changing in tint according to the local colour seen. No real attempt is made to paint individual components of the landscape. (Chapter 3.)*

Studio Workshop 2

GRAPHIC INTERPRETATIONS

Do as much sketching from observation as you can. Never be without a small sketchbook. Spend what might otherwise be idle moments, like waiting for a bus or train, recording in your book something you can see. Try to render with your line work the form and texture of your subject, by a good description of the light direction and of tone values. Examine some of the many drawings taken from my old sketchbooks, that have been reproduced through this book, and begin systematically to fill your own book with your personal observations.

Do experimental sketches using a variety of drawing tools, pencils, pens, Conté, charcoal, etc. Above all, try out drawing with a finely pointed brush using Indian ink.

TEST-YOURSELF EXERCISES

1. *A pot in open line drawing*

Take only one object, a pot, jug, can, or anything quite simple in shape, and set it a few feet from a window or light, with a neutral background, so that one side is in light, and the other in shade. With HB and 2B pencils make a careful drawing of this on drawing paper. Keep your lines open, i.e. apart, and let them follow the nature of the surface to describe the form of it (Fig. 11*A*).

2. *Losing the outline*

Take a piece of tracing paper and pin it over the drawing done for Exercise 1 above. Without using any outline whatever, follow your own tonal values but express them in the manner explained by Fig. 11*B*, i.e. lines of character, varying in thickness and in pressure to secure light and dark. The outside of the object will be indicated merely by alteration of tone and in places will be lost entirely.

Fig. 13. Brush drawing. *Cultivate your skill in drawing with the brush. Layouts for watercolour are best made this way.*

3. *A pot in mass shading*

Now draw another object and try to forget outline except for indications of the shape of the silhouette against the background, and with pencil, charcoal, or Conté, using the technique shown in Fig. 11*C*, get as much form as you possibly can in your drawing so that it appears to have a third dimension.

These three exercises are calculated to instil a stronger feeling for form, and if you have the courage and tenacity you will try them out several times each before you are satisfied.

4. *Line and wash*

Find a simple building or shed and use this for a pictorial composition. Do your line work with brush and Indian ink, remembering to express the utmost tonal value with the brush line work. Then apply a wash all over it, varying the tint according to the local colour of the subject, and allowing the colours to merge at will. For this, study Fig. 12.

5. *Drawing with the brush*

Take another view of the same simple building, and make another drawing with blue pigment and entirely with the No. 2 brush, using lines of character as in the pencil drawing, Fig, 11*A*, and dispensing, as far as possible, with any outline. Make the character in the lines do the work of modelling. No wash is needed for this, just a plain drawing as in Fig. 13, except that it will be a building done with the brush. This is to get you used to the habit of drawing with the brush, which is the preliminary task in all painting.

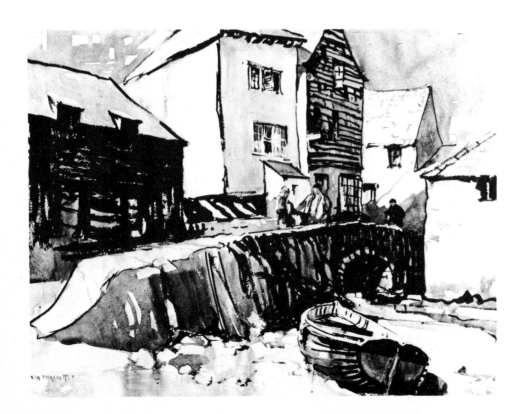

Old houses, Polperro. *A line and wash painting.*

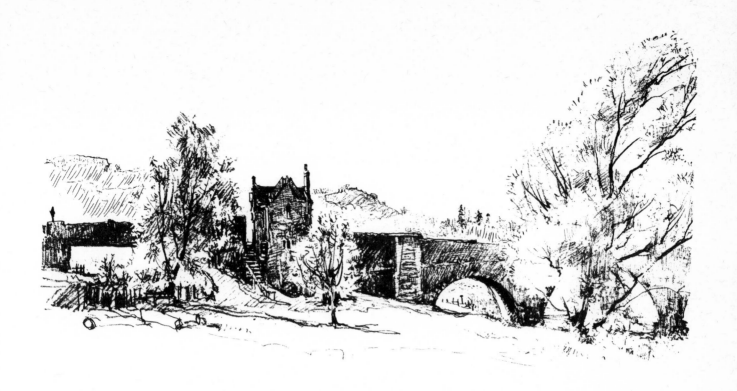

4 *Ways to Watercolour*

After the essentially graphic procedure for line and wash, the other ways to develop painting with pure watercolour in the Jack Merriott method fundamentally revolve around two main themes.

1. *The direct method*

For this a direct approach is made painting in full deep tone the main centre of interest, on the dry paper (Fig. 15). The beginner could use a pencil or charcoal draft to assist him with this, but the accomplished draftsman will paint this focal area directly with the brush. So this calls not only for some skill in drawing, and the previous practice exercises were intended to develop your ability in this direction, but also for careful analysis of your subject, in order to assess which part of it will comprise the centre of interest, where you will place it, and the depth of tone and colour needed to portray it.

2. The controlled wash method

A controlled wash approach is working from the start in one big wet wash all over the paper. The object of this is to endeavour to obtain, from the start, effects of atmosphere and light, for the wash will be developed using various tints and tones, and an attempt to control it by adding or lifting colour, before allowing it to dry throughout, prior to the final touches of well drawn accents. In other words, this is a wet-in-wet method (Fig. 14).

Clearly the main difference of approach in these two methods is that of the order of delineation, whether graphic expression is used from the start or minimized at the finish.

Both these methods are somewhat opposed to the normal one adopted by many amateur watercolourists, of making an initial pencilled draft, a start with painting the sky, and then the various components of the landscape painted part by part, filling in the drawing.

Here, then, is the full description of both methods in Jack Merriott's own words.

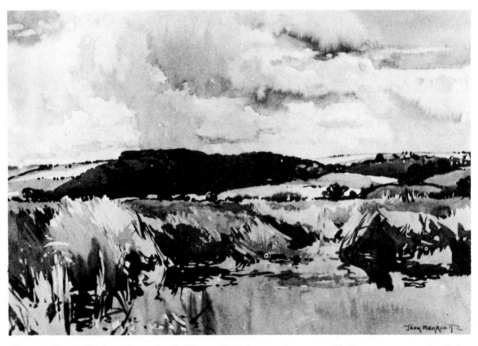

Fig. 14 Controlled wash method. *First a backing wash was applied to represent the light and atmosphere, then local colour covering the sheet. While this was wet, additional stronger colour was put in to provide darker tone values where required. When dry, well-drawn washes in deeper tones were used to describe more detail.*

THE DIRECT METHOD

This approach involves an attack directly on the centre of interest from the start on the dry sheet of paper. I employ this method when I am emotionally excited and some particular feature or effect in the landscape has so fired my enthusiasm that I am impatient to record at once the essence of the scene before it changes. Perhaps a church tower in the middle distance is thrown into strong relief by a passing cloud, or a mountain is partially obscured by a heavy rain shower; a sailing boat approaches the entrance to the harbour, against the sun, its deck and gunwhale a dazzling silver; or some other fleeting effect of beauty occurs. In these circumstances I must get down quickly the special feature or centre of interest. The main difficulty in this is judging the correct depth of the tone values. Being painted straight on to the white paper, they appear darker than they should.

In my colour plate, "The Westering Sun" (Plate IV), I first painted the group of dark trees behind the golden-edged stooks. These appeared far too dark until I had painted in at a later stage the fields behind them, which then

Fig. 15 The direct method. *The cluster of houses and Church at Damme, Belgium, was first painted in strong tone value, to record a quickly passing effect of light. Broad washes for the sky and fields were superimposed, and finally a similar loose treatment was used for the row of poplar trees and their cast shadows.*

put the trees into the right relationship. This method must naturally be as rapid as possible, for brief natural effects. "The Westering Sun" was painted in about half an hour.

This method is also useful when the atmosphere is damp and washes will not dry. In such conditions the controlled wash would be quite uncontrollable.

THE CONTROLLED WASH

This is an entirely free and loose watercolour technique, no pencil or pen lines being used at all, but, as its name implies, forms are expressed mainly by controlling the wet wash and any outlines required are drawn with the brush. One proceeds from the broad outlook to the narrow, from the generalization to the particular, from space to detail. An example of this method will be seen in Plate III, "The Village Pond."

Broadly speaking, my mental processes which I attempt to express can be roughly summarized thus:

(a) The creation of a nebulous atmosphere in harmony with the scene which will enable me to pass through and beyond the surface of the paper into a world of imagination in which I may breathe and look about me. This we will call *depth*.

(b) Then I am able to observe the main forms and colour masses which interest me: *form*.

(c) Finally, I can dwell more particularly upon any exciting details: *detail*.

In this order, my thoughts are expressed thus. A very wet wash of colour is applied to the whole sheet, varying in tint and depth according to the scene before me. While this is very wet, colours may be altered, tones deepened by the addition of colour, or reduced by lifting with a semi-damp brush. The first broad wash can be controlled quite a lot in this way, and forms stressed by adding or reducing tone, or by line drawing here and there with a pointed No. 5 brush. When a general misty idea of the scene is achieved, this is then allowed to dry. Finally forms are brought out where required by direct blots of pure colour and a strong detail here and there.

It will be seen that by this means much of our picture is painted in one wash only, and at the most with only two or three applications in parts. The result is an appearance of cleanliness, purity and spontaneity.

Just one more point before you get down to your exercises. The angle of your drawing board may be anything between the horizontal and the perpendicular, but things to remember are these. If you paint on the vertical plane your tones and colours must be stronger as, in a wet wash, they will drain down to the bottom of the paper to a large extent and, unless you are using a rough paper, the result will be very weak. Also, channels of colour will often suddenly flow downwards through passages which you wished to keep clean. This can be very distressing until it has happened so many times (it invariably does when I am demonstrating before an audience) that you gain a philosophy

which hopes it can be put right in due time, but refuses to be diverted from the particular purpose in hand.

If you paint on the horizontal plane, it takes longer to dry, is inclined to puddle, and is conducive to granulation on rough paper. Washes stay where they are laid, and dispersal on wet paper is reduced.

The ideal, therefore, is normally a position between the two. I use an angle of roughly 20 degrees to the horizontal, but I use an easel outside, and a drawing desk in the studio, which enable me to alter this angle for different effects if I wish. Whether you wish to use an easel, have your board on your knees, or, if working indoors, place it on the dining-table, kitchen sink, or studio divan, it is advisable to have the power always to alter the pitch when necessary for the control of washes.

Both these methods of painting in watercolour are described in detailed, step-by-step stages, in later chapters of the book.

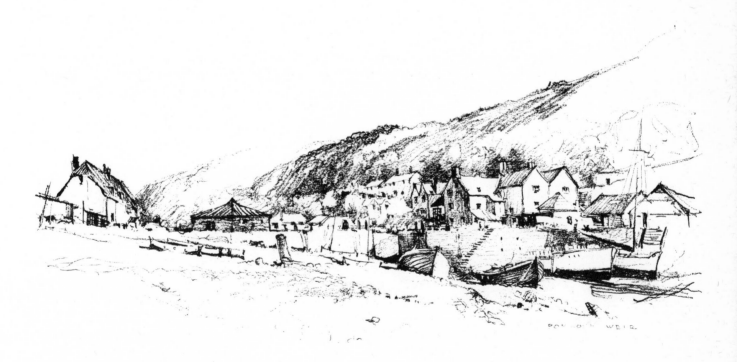

Porlock weir. *Getting tones with soft pencil.*

Old Houses, Fittleworth. *In this line and wash painting note how boldly the brush has been used with Indian ink, to produce the line.*

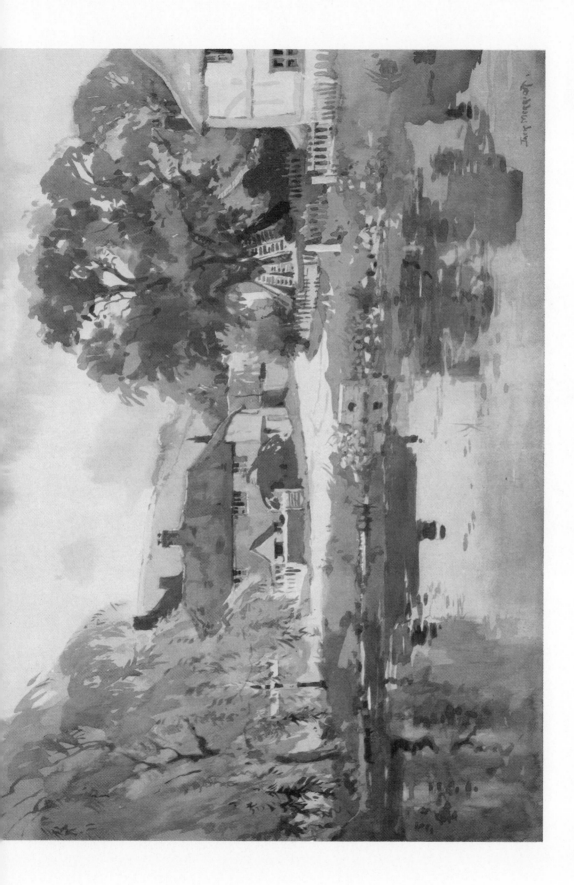

THE VILLAGE POND
Watercolour 15 × 21 in.

Plate III

*Painted in the controlled wash method. A close
look will show you how the first covering wash
described the tint of all the passages of light tone
values.*

THE WESTERING SUN
Watercolour 15 × 21 in.

*This is an example of a direct method by first
painting some particular feature of dark tone value
in the landscape, prior to preparatory washes. It is
a method for quickly-changing light needing
confident drawing skill with the brush. In this
case the dark trees behind the golden edged stooks
were painted first. This vividly sets up these
highly lit edges caused by the setting sun, for a
second direct painting of the shadowed areas in
the stooks themselves. (Chapter 4.)*

Plate IV

INCORRECT APPROACH

Some common faults are shown here. (a) Composition: tree too central, horizon cuts picture in half and figures badly placed. (b) Tone and colour: the distance is too strong in value and too warm in colour, middle distance and foreground too weak.

Plate V (top)

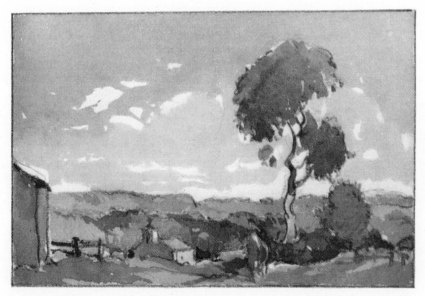

A BETTER APPROACH

The tree, when pushed to the right, is raised in height and dignity by lowering the horizon. Cloud shadows, giving stronger tone to the middle-distance trees, concentrate attention round the base of the tree. More subtle colouring is chosen, cool in the distance, with warmer accents in the foreground. Irregularities in the latter are exploited for a better tonal effect.

Plate V (bottom)

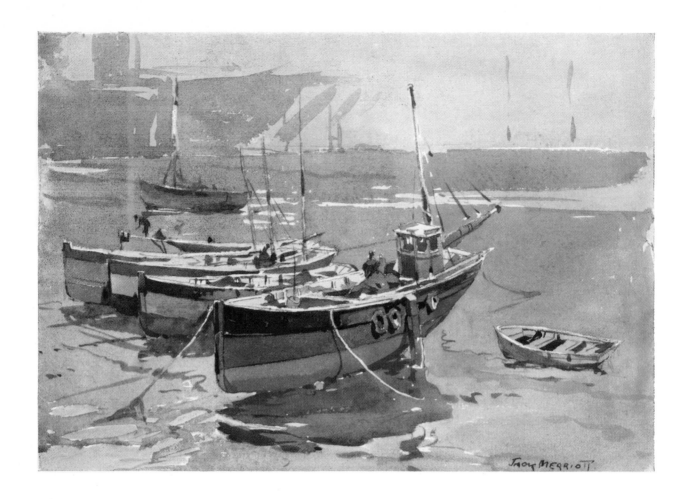

BOATS AT LOW TIDE
Watercolour 11 × 15 in.

*This was painted to help the student with his
problems of colour and tone value described in
Studio Workshop 3. A great deal of experimenting
with colour mixing is required to discover the
characteristics of watercolour, and what the result
will be when it has dried on the paper. This study
is intended to help you with your selection of
colour and portrayal of tone value.*

Plate VI

HARTLAND, DEVON

5 *Characteristics of Watercolour*

If you have followed the text, and worked hard with the suggested exercises so far, you should by now have acquired some sensitive appreciation of form, and the ability to express it in line and tone. Also, you will have obtained some knowledge of the behaviour of watercolour pigments on different papers and surfaces, and the three methods by which such experience can be applied. It is important for you to remember that observation, appreciation and thought must proceed in advance of your practice work, for this will extend your ability to express yourself.

In this chapter I want chiefly to consider some of the various qualities which we should try to cultivate in picture making. I will refer to them as they come to my mind, rather than attempt to place them in any order of priority, since ideas of precedence differ according to the nature of the individual.

I have attended a wide diversity of amateur painting exhibitions, and I am sure you must have shared my experience of thinking to myself on leaving a show: "A very good show," "A fairly good show," or "A rather indifferent show." But usually there are a few paintings by one or two members which are quite outstanding, and one remembers these. In what respect do these

differ from the remainder? In seeking an answer we shall surely find just those qualities worth cultivating.

TONE VALUE

This is a comparative quality and refers to (1) the relative lightness and darkness of colours when seen in the same light, and (2) the degree of light which reaches the eye from objects or optical impressions when related to the source of light.

Dealing with (1), if you compare patches of deep yellow, dark brown and deep ultramarine blue on a sheet of paper in an ordinary light, the yellow will appear lighter, or have a higher tone value, than either the brown or the blue. By the addition of water to these colours, each may be raised in value or made lighter, according to the proportion of water to pigment, and each can be so varied that a very deep yellow can be of a darker tone than a light blue, whereas when compared with a cake of ultramarine blue, the latter, being nearly black, is much the darker. This might be called the local tone value.

Now referring to (2), the tonal value here depends upon the amount of actual light being received by the object from the source of light, and it is influenced, to some extent, by the tonal value of the object or colour itself, referred to in (1).

Example: A yellow boat in the shade of a tree may be darker in tone than a brown or even black boat which is in bright sunshine, but will yet be lighter in tone than the shaded brown mud upon which it rests. The shaded wall of a white Cornish cottage may be darker in tone than its dark blue slate roof, which is catching the direct rays of the sun.

When making a sketch, it is essential that we watch these tonal relationships very carefully. I can say without hesitation that the vast majority of pictures I am called upon to criticize suffer from lack of true appreciation in this respect; I cannot emphasize the importance of this matter too much. It is so important that Studio Workshop practice exercises Nos. 2 and 3 have been designed to help you to comprehend this subject fully.

It is impossible to imitate Nature even if we so desired, since her range of tone values starts with the sun itself as highlight, and at the other end of the scale is the darkness of a deep cave. We have white paper and black paint, both seen in the same light, so that with this limited scale it is very important not only to be able to recognize light tones and dark tones but also the relationship of these to each other and the subtle relationship between the intermediate tones, if our picture is to be convincing. My advice, then, is to cultivate your observation of tone values.

Before proceeding any further, I must stop to take a look out of my studio window, for here is a lesson in observation for us all. The stretch of sea at the harbour entrance is a deep grey-green, and beyond, the rocks rise in purple-grey shade against the sun, surmounted by a silvery green border and a row of dark grey conifers, and then by the sky of atmospheric blue.

The sun, a little to the right, is screened by the window frame, but a wet patch of jutting-out rock, just above the water line, is reflecting the rays. The water is comparatively calm in the protection of the headland, but what has particularly attracted my notice and admiration, is the sudden flash, here and there at frequent intervals, of patches of silver, apparently as brilliant as the sun itself, over the dark surface. They sweep across rapidly from the right, fan out and make the most delightful designs, and then, as suddenly, dissipate. This, of course, tells me that a strong gusty wind is blowing from the valley, and as each gust hits the surface of the water, it whips it up into small wavelets which, like the rock, reflect the direct rays of light to my eyes. What contrasts of light! A poem of colour and movement, which I can enjoy in the protection of my three-foot Cornish walls, to be told so much more satisfactorily in colour than in words.

But this is beyond our scope at the moment: let it suffice that we have gained something in observation to which we can refer back later.

Now let us refer to this observed scene I have described in terms of tonal appreciation. In this we should be careful to compare the relative values of the silver-light patches with the illuminated rock, and both with the stretch of unruffled water, and these again with the mass of tone constituting the shaded headland, with the dark trees and with the sky — all being compared with one another. This does not mean that we should carefully study each crack and hollow in the cliff face, each wavelet, each clump of grass along the sunlit border, for it is this sort of thing which blinds us to the broad truths.

Half close your eyes and compare the main masses in the landscape and if you get these right you will be more than halfway there. Slight modifications may be made afterwards if necessary, providing they do not interfere with the main mass of tone. But from the commencement of painting you should decide definitely which is your lightest light and darkest dark, and make a note on your sketch, or on a separate sheet of paper, of the actual tones and colours you propose to use to represent these. All other tones can then be related to them.

I have been asked, "Do we all see colour alike? If so, why do several people, painting the same scene, use such different colours?" So far as I know, with the exception of those people who are colour-blind, or suffer in some other way from abnormal sight, the image reflected upon the retina of the eye is the same with all human beings in respect of both tone and colour.

But the act of seeing involves not only the reception of the image in the eye but also the reception by the mind of the impression conveyed by the optical nerves to the brain, and this is where the differences occur. Have you ever been looking at a thing and not seen it? Of course we all have. This is when the mind is otherwise occupied or is unprepared at a given moment to receive such impressions. It all depends, therefore, upon the condition of mind as to what we see.

So with colour. Our capacity for seeing colour varies under different conditions and is influenced as follows:

(a) *Mood.* How much brighter colours appear when you are in a happy frame of mind compared with when you are feeling "blue."

(b) *Contrast.* Mix some monestial (phthalo) blue with a little viridian to make a kingfisher blue and paint a circular area about 2 in. in diameter. Surround this with a large area of cadmium yellow and the circle will look quite blue. Now surround it with deep ultramarine blue and the circle will appear green. Similarly, cadmium red on a cadmium yellow background appears red, but on ultramarine blue will appear orange. Red on grey will make the grey appear cold; blue on grey will cause it to appear warm. You will be able to discover many other contrasts.

(c) *Association.* If you were in a room lit by a red light and, when you had become accustomed to the light, I showed you a pot you knew to be blue in daylight you would probably say at once that it was blue. How can this be when it is lit by red light? It must be purple! Likewise you say that the grass is green, whether it is lit by a yellow sun or a blue sky, when this cannot in fact be so. We know the local colour of grass is green, and feel we must paint it so, but when one looks over a field of wet grass, each blade bent with its polished surface reflecting the blue of the sky overhead, we should realize that we are not seeing green, as we think, but a blue-grey. The yellow light of the sun upon a white wall makes the wall yellowish and no longer white. Colours are therefore influenced by the colour of the light falling upon them.

One need not necessarily adhere to truth of colour if, by departing from it and using a different colour, we can stress our feelings more intensely. Some days I feel calm, and am impressed by the delicate greys of Nature, whereas at other times I am more cheerful and excited, and use the whole galaxy of my colour box.

Colour appeals to and excites the senses. The greatest degree of excitement is produced by primary and secondary colours in juxtaposition, such as red

and green. Quiet and peaceful emotions are induced by the various tertiary colours and greys. Some colours are discordant when together, such as cerise and vermilion, but, like notes in music, can be introduced into the same harmony by the interposition of greys.

As I have said, here is a means of expression of many moods and in the hands of some artists this takes priority of place.

ATMOSPHERE – DEPTH

A feeling of recession can be obtained by the use of sharp definition and positive colour in the foreground and softened edges and neutral colours in the background. This is aerial perspective and it should be supported by linear perspective, which will be touched on later.

PATTERN, DESIGN, COMPOSITION

This is the disposition of shapes, tones and colours within the confines of and in relation to the rectangular shape formed by the outside edges of your paper. One can appreciate good and bad design in a carpet square or table-cloth and the same applies to a picture, regardless of the subject matter. I frequently turn a picture upside down to judge this quality.

In a picture the pattern is governed by the selection of the subject and the placing of the ingredients within the rectangle. When required, certain objects may be altered in position with reference to the actual scene in order to obtain a happier arrangement of masses. This is composition, and is demonstrated in Plate V, which is referred to later.

SPONTANEITY – SIMPLICITY

These qualities are best described as thoughts expressed simply and briefly to the point with economy of means and without apparent labour. This comes as the reward for earlier hard work and experience.

FEELING – POETRY

After many weeks spent imprisoned within the white walls of a hospital ward, I escaped on crutches from the hospital precincts. The sun shone down from a cloudless blue infinity, and I limped to a nearby field of cow parsley, where I sat down on the rich brown earth. Before and above me rose one large blossom, its cool green stems and foliage, and the delicate lacework of the green-white flowers traced sharply against the blue of the sky. I looked into each small flower and inhaled the heavy perfume. I was the first to look

into the secret beauty of this one among the myriad blooms of the field, and I felt its poetry had no existence until that moment when it was seen and appreciated. If only I could have expressed those thoughts in paint; that would have been poetry and feeling. I would have washed in that deep blue sky, gradually weakening in colour and tone as it approached the dark grey-green of that row of dignified elm trees growing in the valley along the river bank. I could not see the water, flowing quietly in the shade of those massive trees; it was obscured by a grey-green light from the many heads of the distant cow parsley. But in the foreground a sharp silhouette demanded my attention and admiration. I should have painted, with affectionate care, that delicate tracery of the flower of my choice as it thrust up its head against the blue sky and dark trees, picking out a leaf and a separate group of blossom here and there to detail more carefully, but generally expressing the beautiful lacy pattern of the plant against its background, and lightly suggesting the warm brown earth from which it drew its life.

TECHNIQUE

This is a secondary quality. It is the manner in which the medium is applied. Clean and clear washes, or blots of good water colour directly applied, add greatly to the attraction of a picture, whereas dirty, gritty, dry or opaque patches of colour hesitantly applied, are undoubted faults.

TASTE

Taste is the ability to discriminate between good and bad watercolour painting, striving for what is good and recognizing quality when achieved. This again grows with experience.

STYLE

This is an unconscious attribute. It is a personal or individual characteristic in one's mode of expression like character in handwriting, and by it an experienced artist can always be recognized. It comes unsought to the sincere painter. If sought by conscious effort it becomes self-conscious and leads to mannerisms, habits, conceit and "pot boiling."

The above qualities are mostly based upon truth to Nature, but whereas there are some truths which may not be falsified some truths can be stressed only by exaggerating them, or by moderating, warping or even falsifying other truths. The artist must have freedom of expression, and it is the manner in which he discreetly departs from truth of tone, colour, form, etc., in order to express his feelings, that identifies him.

Let us imagine we have just made the sketch before the rural scene depicted in Plate V, and we now proceed to criticize the work done in the top sketch. The tree, of course, is much too central, and the tone too weak and flimsy. The distance is too strong and warm in colour, the bush on the right of the tree just balances the church on the left, the horizon cuts across the centre of the picture, and the fence is equidistant from this and the base of the picture and is parallel to both. The colour and tone of the shed and the figures are too strong, and the placing of the latter bad, as the attention is drawn to the outside corners of the design.

After criticizing a picture, I have frequently received the reply, "But it was like that." This is no reason for choosing a subject which, in itself, is not good. Let us now imagine that we can retire a little from the scene where the fence will become less important, as in the bottom sketch, Plate V. We may raise the tree a little in height and dignity by lowering the horizon, and pushing it over to the right of the picture, and separating the church more. Irregularities in the foreground are made the most of, and cloud shadows on the middle-distance trees are recorded to concentrate the attention round the base of the tree, a much more pleasing position for the figures. The position of the shed is all right, but the tone is very much reduced. By comparing the two illustrations other improvements will be noticed as a result of a little thought, imagination and composition.

CANTERBURY

Studio Workshop 3

EXPERIMENTING WITH COLOUR

You cannot do too much experimenting with your colour box to find out the characteristics of watercolours on wet and dry paper.

1. *Applying a wash*

Apply a wet, light red wash over a sheet of paper and while wet, float in to the centre a large blot of French ultramarine blue, about 2 in. across. This will immediately start to run out in all directions. Try to control it on one side only by stopping it with a semi-dry brush and add a little more light red where you have lifted it to make up for the lost light red with the blue. Add some deeper blue in the centre and control again in the same way.

Just before this is dry, take a semi-dry clean brush, No. 4, and, freehand, draw a straight line down the centre of the damp page, thus lifting off the colour and leaving a pale, softened line like a mast. The colour may still be inclined to run in, but try to prevent it. (Illustrated on right.)

Try the above with other colours together, watching how each merges and which is the dominant in its infiltration.

Do not be discouraged if the washes simply refuse to be controlled. It is like that at first; one needs patience and determination and a great deal of perseverance.

2. *Tone and colour*

Take three sheets of stiff paper or cardboard, about 8 x 11 in. (any cheap cardboard will do so long as it has a white surface which will take a plain wash of watercolour). Mix some very strong colour, cadmium red, cadmium yellow and French ultramarine blue, in three separate saucers, sufficient in each to cover one sheet, and with a No. 9 brush apply a good wash, unvarying in strength, over the whole of each surface, and allow to dry. This will be good practice in laying on a large wash, besides serving our next purpose.

You now have one red, one yellow, and one blue sheet of cardboard.

Divide the length of each into four by ruling and slightly cutting three lines across. Fold back at each cut (as Fig. 16) and set them upon a table alongside each other, with the light directly from the left-hand side.

Make a careful drawing of these as seen from the front, and then paint in each panel, correct in tone and colour. You should particularly note (a) how the true local colour is seen in the second panels (counting from the left), turned slightly away from the light, (b) the depth and tone of colour in the cast shadows, and (c) the influence of reflected light and colour from the first panel of the second group into the last panel of the first, and from the first of the third into the last of the second.

These experimental exercises with colour and tonal relationships lead to a final interpretation in landscape painting as in the illustration "Boats at Low Tide" (Plate VI).

TEST-YOURSELF EXERCISES

1. Set up a group of different-coloured books and make a watercolour study of them in the manner of Exercise 2. Arrange your book group in good side lighting to get the best effect of colour and tonal relationship.

2. Set up a plain round coloured pot or jug and make another study trying a controlled wash method. In this the varying colour and tone values will no longer be seen in sharply separate panels but in one complete gradated wash.

3. "Boats at Low Tide" (Plate VI) is an example of both the above exercises applied to a seascape. Now go out and find some similar simple subject, not necessarily boats — carts, sheds, buildings or anything where different forms and colours are brought together. Make a drawing, then wash in the colours, watching the tonal alterations and effects of one colour upon another, and the effect of light direction on the tone value of them.

Fig. 16
Exercise in tone values.

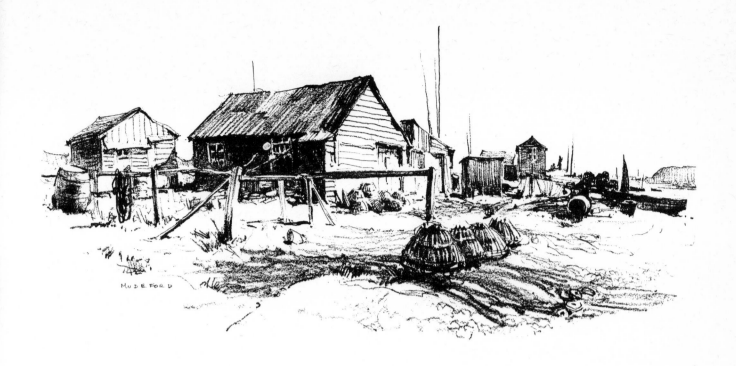

6 *Painting a Still-life*

When I see the term "still-life," it invariably recalls those early days of my childhood, sitting in a crowded classroom with drawing board, sheet of drawing paper and a gritty pencil. On the table before us was an uninspiring group of odds and ends — vegetables or even those appalling white wooden cubes, cones or cylinders — which we proceeded to draw very laboriously in full tone. How uninteresting and unimaginative it sounds now. In some ways, no doubt, it was a sound foundation, though hardly calculated to inspire excitement and enthusiasm. I liked it just because it was "the Art Class."

We cannot expect to avoid the spadework in our training, but it depends on us individually whether this is to be interesting or boring. When once you can draw and describe tone and colour reasonably well there should be no object which can fail to give you joy in the effort of making a sketch and seeing the third dimension or a good pattern appear beneath your hand.

Apart from the fact that still-life is an essential step in our training for landscape painting, it is, of course, an individual branch of painting which can be very satisfying in itself. Look at the work of Chardin and Van Gogh as just two examples, so different in their attitude and both so delightful.

You will see how still-life becomes part and parcel of landscape and

interior work if you look at some of the superb examples of Van Dyck, Maclise, the Dutch masters and many of the modern painters. What is a group of boats on the shore, but a study of still-life? I have so often heard the remark "I cannot paint foregrounds." It may be that only occasionally do we wish to draw attention to the foreground interest in a landscape, but whether this be detailed or simplified we shall be better able to detail or suggest a fence, a stony bank or a boat, if we have studied still-life subjects in the studio.

The application of still-life to landscape is demonstrated in Plate VIII, entitled "Fishermen's Gear."

I have done very little still-life painting for some years — not because I do not like it but merely that landscape painting demands so much of my time that I never get the chance to get down to it except when teaching. I shall make this an opportunity to do something myself, and in view of the importance I attach to the subject, I propose to take you with me, stage by stage, through a painting. I am going to enjoy myself; I hope you will also and that it will encourage you to get down to a similar study yourself.

SETTING UP THE GROUP

Do you wait for somebody to arrange your group for you, and when you have finished your painting say "All my own work"? The arrangement of the objects is just as important and calls for just as much thought, originality and taste as the act of painting. As you select a landscape, so you select your group, whether for design, colour association, lighting, or any or all of these qualities; the arrangement will be the first determining factor in whether your picture is a success or a failure.

So often when I have asked a pupil to select a group from a delightful array of glistening dark bottles with dusty bases, bowls, fruit, coloured vases and drapery, I subsequently find he has set up a complicated medley of vari-coloured items, quite unrelated both in colour and character, which will take all day to draw without touching colour, resulting in a sense of frustration at the end of the day. Again, as in landscape, simplicity should be aimed at. Three or four objects should be sufficient, providing they are well placed and have some relationship to each other. For instance, one would hardly set up a jug, a piece of coal and an apple, unless these things had some particular significance.

Let us now go down into my quayside studio and see what we can find. Down in the stone fireplace recess stands one of my old earthenware jars, called a stainer. The light falls full upon it from the left, lighting the salt-encrusted rim, and the warm terracotta of its ample shoulders, contrasting with the darkness of the recess behind. I love these jars, which are indeed a part of my studio, so here is my main subject.

Now for a polished surface to set off the matt texture of the jar, a small

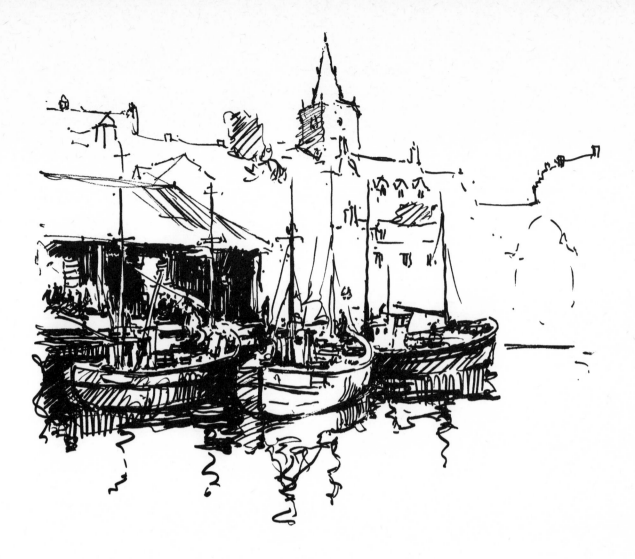

earthenware dish with a glazed interior to place in front of and obscuring part of the base of the jar. We will place these on a piece of striped fabric suitably draped so that the eye is led up the stripes and folds to the centre of interest immediately to the left of the jar.

Finally, one or two items to associate the group with the marine character of the studio, an old wooden pulley with rope attached, an iron hook, and two or three large rusty iron nuts, all retrieved from the pilchard factory of which my studio once formed a part. Placed in the background these will help to give depth.

Now we are all set we have to decide just where we shall sit; near or away, above or on a level with the top of the jar. I prefer to look somewhat down on to the composition, especially as the objects are just above floor-level, so I place myself on an ordinary chair roughly six feet away, my sketching easel before me in such a position that I look in the direction of my right shoulder to see the group. Thus the easel and drawing board will not obstruct my view. A stool on my right accommodates water pot, brushes, rag, etc.

TRYING OUT A COMPOSITION

I take a quarter imperial sheet of drawing paper and fix it on the board. Then I look at the group. I decide it is clearly a triangular composition. So, with an HB pencil, I draw the two lines *AB* and *BC* (Fig. 17), which indicate the general trend of two sides of this triangle with the apex falling on the further edge (or upper extremity in the design) of the jar. Next I fix points *D* and *E* and roughly sketch the ellipse of the jar mouth seen in perspective. A vertical line drawn down through the centre brings me to point *F*, this being the centre of the base curve which is then drawn in relation to the rim. Lines drawn down from *D* and *E* at the correct angle will place the shoulders of the pot, the width again being related to the rim. Next I rough in the main lines of the drapery and the placing of the pulley and the bowl, by relating to each other all those points marked with a cross as before.

This finally fixes the composition, and by the rapid scribbling in of a few hatched lines to represent the main masses of shade, I get a fair idea of what the picture will look like as a design and can imagine the colour.

Fig. 17 Trial composition. *Here's a way to crystallize your compositional ideas.*

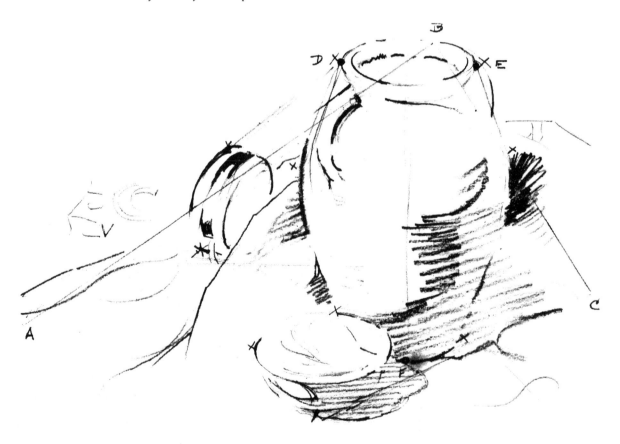

No. I am too near the objects and they occupy too great a proportion of the paper. I will try it again by retiring about two feet and proceed exactly as before but allow more space around the objects. (See Fig. 18.)

I was in doubt as to whether to include in the arrangement an old iron boiler which stood in the recess behind the pot. This is roughly indicated, but I rather think that this mars the simplicity of the group and I shall not require it. I draw lines *A* and *B* to see whether I should like a squarer composition, and finally decide to leave line *B* but delete line *A*.

As in all my work, you will notice I started with the broadest and most essential lines of the composition, then inserted important points of the main masses, and gradually built up from the broad truths to the more particular details. If the large masses are correct then the smaller details will come right.

The image of the still-life as it will appear in my painting is now pretty clearly impressed upon my mind, and I am ready to express that in water-colour. I choose to paint the picture in the controlled wash method.

Fig. 18 A tonal rough. *Broad shading with a graphite pencil gives a statement of tone values. This will assist when you start to paint.*

DRAFTING THE LAYOUT

Now a sheet of the watercolour paper is pinned on the board. We will deal with this in the controlled wash method, and so dispense with the pencil line. With the No. 9 brush, I transfer a little water into the palette and mix a fairly pale ultramarine blue for the rough sketch-in. This is done with the No. 2 brush in much the same way as the pencil sketch, indicating the principal points of the composition, relating them to each other (without the connecting lines), noting the shape of the main triangle first. I observe the depth of the ellipse; the width of the rim compared with the height of the jar, and what proportion of this height the pulley is in length; the distance between these two objects compared with the width of each; the intersecting points of the foreground bowl with the jar.

All items of proportion of this description are most important, and you will find that precisely the same problems occur in landscape, so that it is as well to make a careful study of this.

When I am satisfied that these location points are correct, I roughly sketch in with the same blue line the outline, here and there, of the jar, its handles, the pulley with rope, the outline of the cast shadows, and so on, omitting the outlines where they disappear into shade or are not easily distinguished, feeling the forms all the time, as mentioned in Chapter 3. Thus only the essential arterial lines are indicated, except that a little more careful detail in drawing the rope, knots, hook and nuts may be necessary.

I will now sit back and look at the group, first as a tonal and then as a colour composition. The main mass of dark is up in the right-hand quarter, repeated in a smaller area in the cast shadow on the right of the jar, the light falling in from the top left. It is the lighting of this group which intrigues me more than colour today. So far as colour is concerned, the whole thing is warm — browns, yellows, reds — and in contrast there is a cool highlight in the portions facing towards my skylight.

PRELIMINARY WASHES

I take up the No. 9 brush, mix a wash of yellow ochre, and light red, and flood this over the whole sheet, adding a little yellow ochre here and there in the foreground, and perhaps a little light red to the right and a little ultramarine blue top right, but leaving one spot only on the paper untouched, the highest light, i.e. the highlight inside the basin. The appearance presented now is a tinted wash all over the paper, varying in colour in places where red, yellow and blue were added, and with the light blue lines and points of the drawing showing through. While this is wet, I lift off some of the colour with a damp No. 9 brush where the highest light falls on the jar. This will give a softened light on the jar compared with a sharp light in the bowl.

A little colour is now lifted off the rim of the jar, the near handle, the

STILL-LIFE
Watercolour 15 × 15 in.

A preliminary wash to represent the colour and value of all the light areas was flooded over the whole sheet, and while it was still wet stronger tints were dropped in where required, and highlights were lifted out. After this dried, further darker washes were applied, beginning with the recess behind the jar. When the main masses were completed, care was taken to minimize final touches so that an atmospheric quality would be retained.

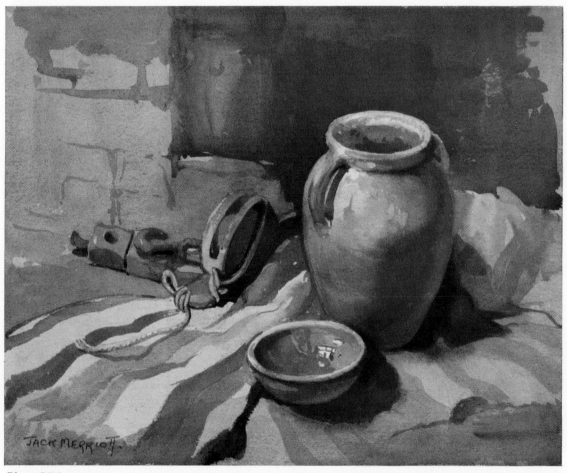

Plate VII

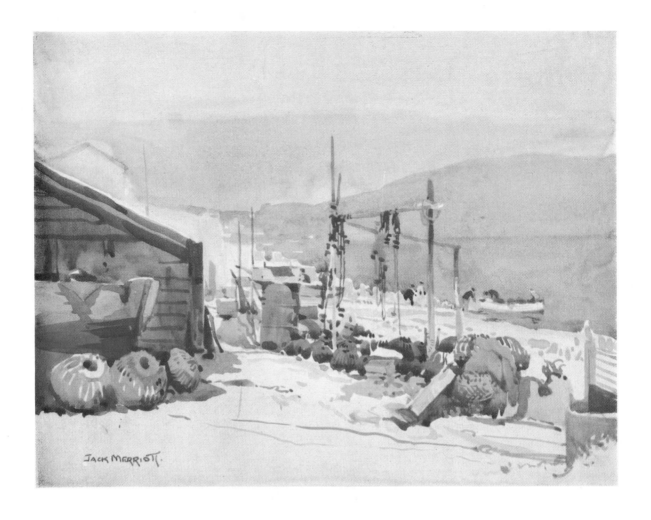

JACK MERRIOTT.

FISHERMEN'S GEAR
Watercolour 11 × 15 in.

*The painting of foregrounds is always difficult.
About this Jack Merriott says: "It may be that
only occasionally do we wish to draw attention to
the foreground interest in a landscape. Whether
this be detailed or simplified, we shall be better
able to detail or suggest a fence, stony bank or a
boat if we have studied and painted still-life
subjects in the studio."*

Plate VIII

pulley and the light passage of drapery on the left of the jar. The wash is not flowing wet but is quite damp, and I take a little yellow ochre mixed with cadmium red and light red and apply this to the shoulders of the jar around the light passage, working this out towards the right and adding some strong ultramarine blue and burnt sienna as I reach the shaded side, lightening to burnt sienna for the reflected light and again running straight on into the cast shadow with more French ultramarine blue and light red. By this time the basic wash may be dry, but if it is not entirely so I must control with a semi-dry brush the outer edge of the cast shadow, to prevent it running out too far.

Next I mix a very strong wash of burnt sienna, light red and ultramarine blue and, the paper being dry, I wash this straight in for the fireplace recess, using this to get a sharp and strong drawing of the top of the jar and letting it run down on the left side for a similar purpose. This is then led into the shadow and shaded side of the pulley, leaving the rope, Then with the same dark colour I paint the slot in the pulley and dark passages in the hook and nuts.

Coming back again to the jar, a little more dark is added where the light merges with the shade, softening off to the right but not out to the very edge. Next some strong shadow (ultramarine blue and light red), is painted to the right of the jar for the definite cast shadow in full tone, closely up to the reflected light on the jar, but not too sharp. This dark tone is carried round the base of the pot and leads straight into the shade and shadow of the bowl.

Next the background wall on the left is made to recede by the addition of a transparent wash of grey blue (ultramarine blue, black and light red), darkening as it approaches the striped fabric and brought to a fairly hard edge. I then add some yellow ochre to the grey in the palette and paint over the right foreground up to the bowl. The bowl itself is painted in the same manner as the jar, with raw sienna and a little ultramarine blue, leaving the edge light. The shade behind can then be painted in to bring up the drawing of the bowl.

THE FINISHING TOUCHES

The main masses are now completed and it merely remains for me to add the finishing touches. These, of course, are very important and we must be careful not to carry them too far, otherwise this will result in a too highly finished and "tight" sketch, lacking atmosphere. I have tried to remain conscious the whole time of my actual distance from the group and to suggest just that distance in my work. I paint in the details of the pulley, nuts and hook with light red, burnt sienna and ultramarine blue, and then with a thin wash of ultramarine blue and black I suggest the stonework of the left background. This last colour is strengthened and used for the shadow of the handle of the jar, and a few touches of raw sienna round the inside of the rim lead into burnt and raw sienna and ultramarine blue for the inside of the jar.

A little pearly colour is added faintly to the highlight in the bowl, with one or two touches of deep burnt sienna and black to strengthen the shadows here and there. A few stains on the outside of the jar, and finally the stripes in the drapery are loosely added, reducing the width of each stripe as the material recedes from me.

The sketch is now finished. You can examine the result if you turn to Plate VII.

I enjoyed that and am sure that I have gained something from the experience. Have you?

Studio Workshop 4

STILL-LIFE AS AN AID TO LANDSCAPE

Still-life painting is excellent preparatory work for landscape, and can be practised in the comfort of your own room. It embraces many of the problems encountered when painting the countryside. The arrangement of the group will be your first test in composition. Do not overdo the number of items in the group.

Your home contains hundreds of still-life subjects. Start now and look around, and register in your mind certain groups of objects *in situ*. Survey them from different viewpoints. Plates on the sideboard with an exciting lighting effect, pans on the cooker, slippers by the bed, or the vase of flowers on the shelf all make delightful pictures.

We shall enrich our minds merely by the contemplation of such subjects, quite apart from trying to paint them, and shall find beauty where we least expect it.

1. To prepare you for succeeding exercises, I suggest you try out the still-life we have just painted together, on your own, following out the procedure I have indicated and the colours I used. You need not make an accurate copy of my illustration. Rough in the group in line as a guide to you to follow out the processes of the painting, the main object being to get that sense of tone, form, depth and light. Remember to mass your darks as much as possible and do not search for details in the shadows.

2. Take a sheet of watercolour paper and give it a wash of clean water. Lift off the drainings at the foot and then proceed to introduce blobs of various very strong colour, letting them merge with each other. Watch how they blend and try to control their outflow. Try this on paper in various stages of dampness and see the best condition you can find for the most control. Try the same thing on washes of different colours instead of clean water.

3. Draw two parallel lines about 2 inches apart and 3 inches long. Wet the area between the lines and then add colour, varying in tone from light on the left into shade and reflected light on the right, to suggest the form of a cylinder. All this is to be done with the wash completely wet, by controlling where necessary. This can be repeated in different colours.

TEST-YOURSELF EXERCISES

1. Prepare a group for a still-life painting. Choose whatever objects you like and arrange them in the most interesting and attractive way you can, in a good light either from the left, right or top front, so long as the light is "one-directional." Bear in mind that a complicated subject should be avoided. Make your group as simple as possible, providing it is not empty and lacking in interest.

2. Make a rough layout of the group, indicating main lines of the composition, arterial and functional lines, and the important points which have been located for correct relationship to one another (as Fig. 17). Also include the main masses of tone (as Fig. 18).

3. Produce a watercolour of the subject by the controlled wash method. Make this as simple as possible in treatment and try to get the true depth of tone within the range of three coats. In my sketch I made the first wash all over and added to it while it was wet. For the second wash I painted in dark tones behind the jar and cast shadows, and finally the details and extra weight in shadows were added. This is the only way to retain the purity of a wash.

Do not expect too much of yourself at this stage, but do your best. Your efforts should be judged on thought and imagination in the grouping, simplicity of treatment and massing of shades, form, feeling of light and space, and colour arrangement. If the result is inclined to be dirty or blobby or the washes do not go right, have another go but remember that the above five considerations are of first importance.

7 Perspective

When we go out sketching together, we shall encounter all kinds of difficulties, apart from those involved in the actual painting. The weather is rarely dependable, and we must learn to put up with the multiplicity of natural causes that may conspire to prevent us producing that wonderful work of art that already exists in our imagination.

Some of you will have to surmount other difficulties, like the choosing of suitable subject matter, and adequately composing it. Another problem for many is that of perspective, and so let me see if I can help you with this.

First of all, what is perspective? It is the art of representing on a plane surface objects as seen in three dimensions.

Among the less difficult objects to be found, the outsides of buildings offer a very suitable subject for our demonstrations, so that some knowledge of perspective is, to my mind, essential. I know that there are many examples among the work of masters, past and present, where the perspective drawing is quite inaccurate and I contend that, being very fine work, they are beautiful *in spite of* the fact that the lines are wrong, not *because of this*. The pictures might have been still better had the incorrect drawing been less obvious. I recall a beautiful picture by Van Gogh of a street scene where the

lines are clearly out of perspective. One can have a reason for purposefully falsifying perspective, and I have seen it done very effectively, but in this instance it was, I think, a careless fault which served no useful purpose.

Aerial perspective is the variation in tonal and colour values according to the distance objects are from the eye. In the open landscape, the further these objects are away, the less distinct they become, the lighter they appear in tone, and the more the local colours become neutralized, i.e. tending towards the blue-grey until positive distance is frequently quite blue. This is under normal lighting conditions and uninfluenced by cloud shadows, local mist and so on. The portrayal of aerial perspective helps to convey the idea of depth or third dimension, by tone and colour variations.

Linear perspective, generally speaking, is more a mathematical science than an art, a form of geometry, and although essential to the architect, if taken too seriously by the painter is liable to become more a hindrance than a help, causing his work to become "tight" (over-careful in draughtsmanship), and lacking free expression and feeling. There are, however, certain rudiments which it is essential to know.

To help you to understand the fundamentals, I would like you to take a sheet of brown wrapping paper, say 16 x 14 in., cut an oblong hole in the centre about 6 x 4 in., and with adhesive tape at the corners stick this mask on a glass window at eye-level where you can see through the hole some buildings which recede from you, something like the scene in Fig. 19. It will be necessary for you to close one eye for this experiment to enable you to focus correctly. Now with your head quite still in front of the hole and about

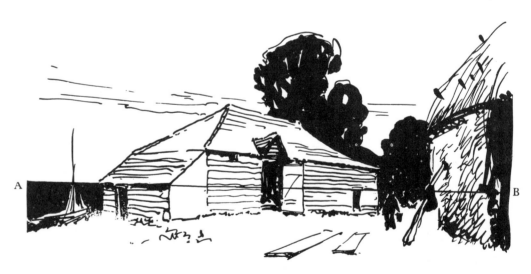

Fig. 19 Ground-level. *The aspect of buildings when seen from a standing position on level ground.*

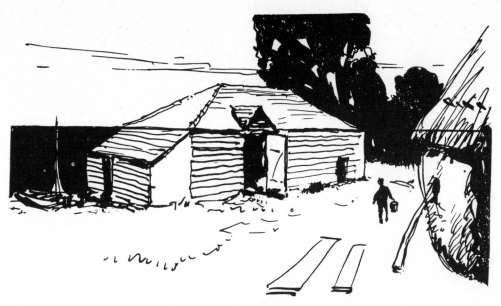

Fig. 20 Above ground-level. *The aspect of the same buildings when seen from an upper window.*

12 inches away from it, stretch a piece of thread horizontally across the opening exactly on a level with your eye and tape this at each end to the mask (see Fig. 21). With your head quite still, imagine you are going to trace on the glass the outline of exactly what you can see through it.

The thread will represent the line of sight or horizon. Everything in the scene which appears on this line will actually be on a level with your eye. Now let us refer to Fig. 19. Line *AB* is the horizon or eye-level, and you will see I am standing on the same level ground as the figure to the right of the barn whose head falls on the same line, and again my eyes are on the same level as the eaves of the lower roof on the left and the tops of the two small doors through which the figure and I could enter. The actual sea horizon also falls on the same line.

Now see how the scene changes when I go to an upper window (Fig. 20). My line of sight is higher and is on a level with the eaves of the upper roof and coincides with the sea horizon which has risen with me. Therefore the actual horizon is always on the eye-level.

Return to your mask. You will observe that all lines which are horizontal in actual fact, but are above the line of sight and receding from you, will appear to slope down as they retire. All such lines which are below the eye-level will slope up as they retire. This is an inflexible rule.

Note from these illustrations how all lines on surfaces which go away from you — roof lines, weatherboarding, ground lines, the two boards on the ground and the stack — converge on the horizon, those above sloping down as they retire and those below rising. When we go to the upper window, the horizon having risen with us, the line of the upper roof which was above the

Fig. 21 Beginner's aid for perspective. *When viewing be sure the horizontal string is level with your eyes.*

eye-level and sloped down, is now on eye-level, and is therefore horizontal. The lines above slope down less than they did and the lines below slope upwards more. I would like you to check this for yourself by using the mask on different levels.

By the laws of perspective, the actual angle that these sloping lines appear to make with the horizon line can be ascertained exactly, but it is quite sufficient if you trust to your observation. In my early studies I soon tired of the geometrical perspective problems, and I have always trusted to my observation. You should observe carefully the amount of slope these lines appear to make, whether up or down, in relation to the horizon, and also to the horizontal and vertical lines of the mask frame. Having noted this you should be able to draw such lines on paper in similar relationship with the outside edges. I will touch on this again later, but meanwhile I wish to impress upon you the need for training your observation in this respect. I have seen so many sketches made where lines are drawn sloping the wrong way, thus doubling the error, and leading to much frustration on the part of the sketcher, who could not understand why his picture was so unconvincing.

When in doubt as to whether a line tends to rise or fall apply the above inflexible rule. It will help you when you are out to decide this, and also in selecting a subject, if you make a small mask to take with you. All you need is a piece of cardboard 5½ x 4½ in. with an oblong hole 2¾ x 2 in. cut out of the centre and a piece of thread stretched across the centre from side to side and from top to bottom.

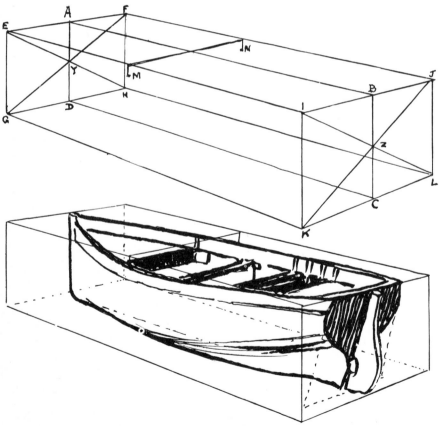

Fig. 22 Aid to boat drawing.
If you think of a boat as enclosed in the familiar and more easily drawn shape of a brick, the correct placing of the subtle lines of a boat, when seen in perspective, is less difficult.

The problems of perspective become more evident with the drawing of
boats, which should always be considered as inseparable from their reflec-
tions if they are afloat. Careful observation is needed when sketching boats.
Their subtle curves and foreshortening continually alter with every move-
ment of the water, however slight, and with the changing tide. Perhaps I can
help you with a diagram, firstly to ensure that the stem or bows are centrally
in line with the centre of the stern plate, and also to assist you in the
construction of a boat, to feel its three-dimensional bulk, its hollow character
and buoyancy, and then to show you what happens to reflections under dif-
ferent conditions of perspective.

The brick is a simple object to draw in perspective. Fig. 22 shows this with
both ends visible, *EFGH* and *IJKL*. To find the perspective centre-line *AB*,
we draw the diagonals *EH* and *FG* and also *IL* and *JK*, and if we erect a
perpendicular line at the intersecting points *Y* and *Z* it will give us points
A and *B* for the point of the bows and the centre of the stern plate in
perspective, and also the line *DC* for the keel. A boat can now be constructed
within this brick by carefully and gradually working out corresponding
positions like *M* and *N*, roughly the widest part at the gunwale which drops
down slightly from the bows. With these points fixed the curves can be con-
nected up with bows and sternplate, which will then be in perspective. Other
positions of thwarts, rudder, etc., can similarly be located.

Fig. 23*A* shows the drop curve of the gunwale from elevation view.
Fig. 23*B* shows the broadening curve of the gunwale to the beam seen in
plan. Fig. 23*C* shows a boat and its reflection seen from near water-level,
whereas Fig. 23*D* is the same seen closer and from a higher eye-level. You
will note how the reflection curve *CD* in Fig. 23*C* is concave, whereas in
Fig. 23*D* it is convex. This is because on the lower eye-level in Fig. 23*C* we
are seeing the elevation curve reversed. In this elevation curve is more than
compensated for by the plan curve, which becomes more and more apparent
the higher we raise the eye and the nearer we approach the boat.

There are a great many different types of boat, according to the country,
and even county, to which they belong. Yorkshire boats are quite different
from those in Cornwall, and in some countries there is a canoe-like tendency
for the gunwale to rise steeply in the prow. However, I have frequently
noticed a common error in the drawing of many English boats, taking the
form of raising the gunwale to the prow in too high a curve, as shown in
Fig. 23*C*. Compare this with Fig. 23*A*, where the gunwale springs from the
stem quite straight.

A Watch the deep curve of the
gunwale from *A* to *B* seen
sideways.

B The broadening curve *AB*
when seen from above.

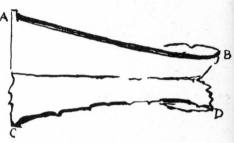

C Run of the reflections when
boat is seen at low eye-level.

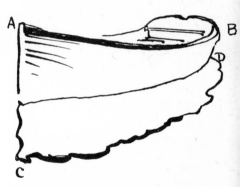

D A different shape of reflec-
tion from the same boat when
seen at a higher level.

E A common drawing error,
showing gunwale rising too
steeply to the prow.

Fig. 23 Boats and Reflections.

St Paul's Cathedral after the blitz, 1942.

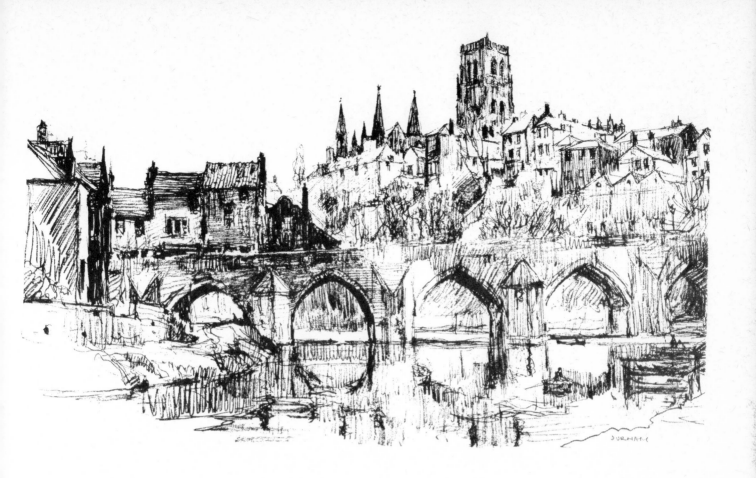

8 *Painting a Landscape Outdoors*

Let me take you in imagination on a sketching trip as one of my pupil on-
lookers. This will help you to enter into my personality, to think as I think,
and enjoy those things that I enjoy. You can imagine you are painting the
picture of the lovely Elvet Bridge, Durham, that I am going to demonstrate
for you.

 Now, a little thought before we start out. Have we got everything? Brushes,
colour box, sketchbook, pencil and eraser, water in the bottle, and water pot?
A piece of string. Why string? you ask. This will be needed if it is windy. The
wind can be most aggravating if you use an easel, but if you cannot find any
suitable protection, you can anchor your easel with a heavy stone or piece of
wood suspended from the centre of it (Fig. 24).

 Hot sunshine, however delightful, can make watercolour painting very
difficult. A wash is liable to dry irregularly and show the separate strokes of
the brush, because each stroke will begin to dry on the warm paper before
the next one is placed. When this is so give your paper a good wash down
with water before starting to paint, and if you wish to put in the sky flood it
in as quickly as possible before the paper dries. Similarly, when you need
softened edges for background or trees, apply a local wash of water before

Fig. 24 An easel anchor *for windy weather.*

painting them in, or alternatively, if painting on to the dry paper, apply a damp brush around the edges immediately to soften off into the background.

The brilliant glare of the sunshine on white paper can be very uncomfortable, besides dulling your sense of colour by fatigue of the optic nerves. In these circumstances, if I cannot find the shade of a convenient hedge, wall or tree, I place my easel in such a way that the sun's rays reach the paper from right or left. These glancing rays are robbed of a considerable amount of their glare by the texture of the paper. You may then find that you are not facing the scene you wish to paint, but it should be no more difficult for you to look towards your left or right for your view.

Are you sensitive to people overlooking you while you work? You must try to overcome this as otherwise you may be always tucking yourself away into out-of-the-way corners to be away from people, and so miss some of the most lovely effects and compositions. What does it matter what other people think of what we are doing? It is our business, not theirs. The main trouble, I find, is that some people will talk and expect me to think about what they are saying as well as what I am doing, so that I frequently ignore any comments, and leave the offender to imagine I am either a foreigner, deaf, dumb or insane. He soon tires of talking to himself.

Right! Let's be off. We are in that grand old city of Durham, with its dominating hill surmounted by one of the most beautiful cathedrals in Britain. The sun shines fitfully between soft cumulus clouds. They may bring showers, but conditions are excellent.

The river draws me like a magnet and I find myself walking along the river bank searching for a glimpse of the cathedral between the trees. Suddenly it appears, its three stately towers rising into the fresh morning air, a warm biscuit colour against the blue-grey sky. I pause to drink in this scene of beauty and in my absorption I gradually become aware of the fact that I am

seeing through the eyes of Turner, Girtin, and Cotman, and am happy in my reverie. But this will not do. I must get down to work and find my own experience to relate.

So I retrace my steps until I see a bridge, and as I approach it my curiosity is aroused and I wonder what may be seen through those intriguing arches. After the ethereal scene I have left behind, here I have something hard and solid, a stone bridge and buildings contrasting with the mystery of atmospheric distance seen through the arches, and clear reflections in the quietly flowing waters of the River Wear. I am tempted to walk under the bridge and see for myself more clearly what is to be seen on the other side, but if I do the mystery will be shattered. Besides, I may be disappointed, and shall be wasting time and effort, or, at best, I may find it so attractive that I may be undecided as to which view to take and end by doing neither. This view is excellent, so I shall make it my subject.

It is about eleven o'clock on a June morning and the sun is fairly high, shining from my left front and throwing the bridge and building surfaces which are facing me into the shade, and shining brightly on to the roofs and walls on the left-hand side of the buildings and on the opposite bank. How luminous these shaded sides are, gathering the warm reflected lights from the bank, and the cooler lights from the sky behind me, and its reflections in the water. There is no wind, so I do not need an anchor for my easel. There may be a shower and even one or two spots of rain are sufficient to ruin a wash when it is nearly dry, so I must be prepared to turn the sketch upside down at the first warning and dash for the shelter of the bridge.

Finally, what about the sun? This will move round from the left to the right, and within about an hour and a half I shall lose all sunshine on the walls. In fact, if the clouds increase I shall lose the sun entirely, and since the sunshine is an essential part of the effect I want I must hasten to record this and remember all I can.

I set up the easel, take out a sheet of Green's Pasteless Board 300 lb, and pin it to my plywood board, fix this on the easel and stand before it, after moving the easel into such a position that the sun will not glare directly on to the paper.

I take out of my bag my palette, rag and brushes, fill the water pot and tie it to the easel. I am ready to begin. Now to find the most pleasing composition from all the material before me. This needs a little explanation.

As you stand looking straight before you, imagine a ray of light, similar to that from an electric torch, passing outward from your eye in the form of a cone of light rays with an angle of roughly 60 degrees. This is your field of vision. Assume you interpose into this field of vision a brick wall two to three yards from you. As when you direct your torch light upon a wall and produce a circle of light, so when you look at a wall you see clearly that portion represented by the circular section of the conical field of vision. The nearer you approach the smaller the circle on the wall becomes, and the further away you retire the larger it grows.

Thus what I see before me is as is shown within the circle (Fig. 25), and I have to decide upon a rectangular part of this area which will make the best design. I show in the diagram five of the many different arrangements from which to choose.

Fig. 25 Circle of full vision.

TRIAL COMPOSITIONS

By looking through my small pocket mask, I choose my arrangement, and on a small scrap of paper I quickly rough out the bones of the composition (Fig. 26A). You will remember we did this for the still-life composition. Points A and B show where the horizon line would be, and the line drawn just below these points represents the level of the distant water through the arches; the

line below that is the water-level at the foot of the buttresses, and you will
note that the bank rises just above eye-level. These are all fundamental lines.
I will add just a little more information to help me to visualize on paper the
picture which is in my mind (Fig. 26B), then I put away the drawing (you
may find it helpful to attach it to your easel as a guide), and pick up my
palette and brushes.

Stage 1. Laying out the design

I mix a weak wash of ultramarine blue and with the drawing brush No. 2
draw in the subject with as few lines as possible, keeping to the main propor-
tions fixed in Fig. 26A and B, and then relating all additional details to these

Fig. 26 (A) Trial composition. *The fundamental lines.*

Fig. 26 (B) *More detail added to help visual inter-pretation of the scene to be painted.*

lines, the height and position of the arches according to the height of the
bridge, distances apart, etc. The mask will help me to decide the amount of
slope of the retiring lines of buildings. I like the trees, which are rather too
far over to the left, so I pull them into the picture so that they are seen over
the top of the bridge, remembering that if they appear above I must make
some alteration to provide for their being visible through the arch. A man
walks into my view and down to the waterside, so I at once take a note of
the position of his head and feet, according to the horizon and the wall
behind. Similarly, when a rowing boat with two occupants arrives at the
best position, I note this also. Then a few lines to indicate the position of
cast shadows which will certainly be altering quickly, and I am ready to sit
back and think again.

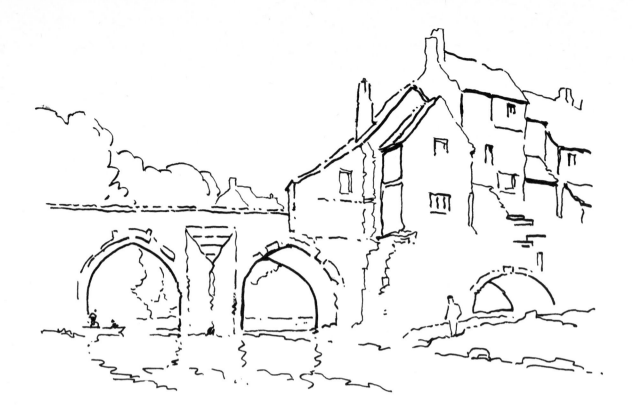

Fig. 27 Elvet bridge. *Stage one. The layout is
carefully drawn in with a fine brush using a weak
wash of ultramarine blue. As few lines as possible
are used, keeping to the main proportions
decided in the sketch roughs. Action that occurs
while this is being done, like the arrival of a man
walking on the bank, and a rowing boat pulling
into view, are sketched in, in suitable positions.*

ELVET BRIDGE, DURHAM (STAGE TWO)

A wash of yellow ochre and light red was quickly flooded over from top to bottom, with the addition of a little ultramarine blue into the wash on arrival at the water. While wet, background trees, parts of bridge, and reflections were indicated with this blue, black, light red and viridian, changing tone value and colour according to the effect required. Warmer tints were used for the buildings and grassy bank, but all was kept soft and atmospheric. It was then allowed to dry. (Chapter 8.)

Plate IX

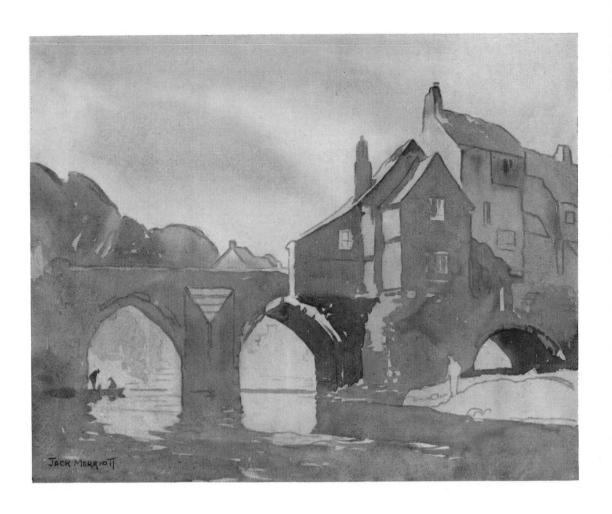

ELVET BRIDGE, DURHAM (STAGE THREE)

A second tonal wash indicating the broad masses of the shaded portions were superimposed. These washes must be carefully brush drawn. Then the deep darks under the bridge and in the stonework were painted, carefully watching the variety of edge, soft and hard, and the reflected light beneath the arch.

Plate X

Stage 2. Preliminary wash (Plate IX)

What do I feel about the subject? A sense of warm sunshine flooding the scene and the cool water at my feet. I mix a wash of yellow ochre and light red, and wash it in quickly from top to bottom of the paper, but adding to the wash a little ultramarine blue and black as the wash reaches the water. This will have to be done with the No. 9 brush or anything larger I may have. I use a shaving brush or sponge for speed, as I wish to get to work on the damp paper before it dries. This is particularly urgent if the air is warm and dry.

While it is damp I paint in with the No. 9 brush the background trees, above and below the bridge, the dark stains on the bridge, and cool reflections in the water with ultramarine blue, ivory black, light red, and viridian, changing tone and colour according to the effects. Then, with varying washes composed of different mixtures of light red, ultramarine blue, cadmium red, yellow ochre, burnt umber and crimson alizarin, I paint the local colour of the buildings. Under the arch on the extreme right I touch in a fresh sunny green of deep cadmium yellow and viridian.

If you look at the illustration in colour for Stage 2 (Plate IX), you will see how these washes, having been painted on to the wet paper, are entirely soft and atmospheric in their edges, and in some places have spread over the outlines. The tones are not very strong so that they cannot upset the drawing, and the darker tones will be added later. I have succeeded in creating a visionary scene which has enabled me to live, as it were, within the atmosphere of my subject, and while it is drying I can sit back and give my attention to the main masses of form within that atmosphere.

Stage 3. Second tonal wash (Plate X)

So far I have only one varicoloured wash on the paper, which represents the highest lights in the subject. I can now wash in the broad masses of the shaded portions in clear washes, leaving the underwash to represent the sunlit passages and any light details such as paintwork round windows, etc., using the No. 9 brush for the broad masses and the No. 4 for parts needing more careful drawing. The edges of the broad masses must all be carefully drawn with the brush, and I must watch the true colour of the scene, making allowance for aerial perspective, that atmospheric grey-blue which modifies the raw red of the tiles and brickwork, and also for the reflected lights on the shaded buildings to the right. I use the same colours as in Stage 2, which are subtly changing throughout the picture. The shaded side of the bridge is washed over completely with a grey wash of ultramarine blue, light red and raw sienna, with the exception of the top edge and the top of the buttress, and the same wash is carried through to the reflections in the water, and is used for detailing the small boat and figures.

The deep darks under the bridge and in the stonework are then painted

with light red, raw sienna, ultramarine blue and a touch of alizarin crimson, watching carefully the variety of edge, soft and hard, and the reflected light beneath the arch.

Stage 4. Final touches (Plate XI)

Finally I am going to add just those interesting details to which I wish to call attention. It is by suggesting these, rather than detailing them, that I hope to lead the thoughts of the beholder and help him to experience the emotions which I am now enjoying. I must not say too much, just briefly explain textures, the airy clouds, stone and brickwork, mosses and stains on the ancient bridge, the pantiled roofs and the various shapes and sizes of windows, warped by age.

First I must explain the light sky without dwelling too much upon the separate forms, since I am more interested in the bridge today. A delicate wash of ultramarine blue and light red is used to wash in the cloud forms, softened here and there into the warm yellow ochre underpainting, and then a light wash of astral blue painted in the left of the sky and the top right. These are softened into the background with a damp brush. While the lower clouds are still wet, I mix ultramarine blue, viridian and light red and wash in simply the trees beyond the bridge, letting the wash form a sharp edge to show the stone parapet, the upper edge softening into the sky as the trees recede. The same colour is used for a little more information on the trees and their shadows on the bank, seen within the arch. A lighter wash is then used to indicate a form within the central arch, just to lead the imagination and enable the beholder to create for himself his own particular dream of what lies beyond.

On reference to the illustration for the final stage, you will see how I have indicated just a few of the separate stones in the bridge below the buildings with burnt umber and burnt sienna, put in with the No. 4 brush, and then allowed to form a patchy stain on the rest of the stonework. Also with cadmium red, ultramarine blue, and raw sienna I have suggested the riblike surface under the central arch, allowing this to form a large blot for the depth of the warm shade. The same colour is used for the underside of the left-hand arch, and for final darks in the figures in the boat and the dark lichenous base of the stonework to the left of them.

For the water, the same colours are used as for those objects that are being reflected, but modified with blues and greens. The darks will not appear so dark and the lights not so light when reflected in water. Reflections are somewhat neutralized both in colour and tone, allowance being made for the actual colour of the water which is sometimes seen in the darker reflections.

When painting in these reflections, I carefully watch the repeated surface forms of the water, and the recurring flecks of light which indicate the flow,

and I draw these with the fine brush, leaving the underwash to provide the light.

When you are putting in these final darks, remember to keep them luminous. Blots of colour, even if on two underwashes, will still appear clean and spontaneous, but if you continue to load on paint, the result will be "dirt" (matter in the wrong place). Do not carry on too long, this results in a sketch which is too detailed and "bitty."

The sketch is finished. I pack it away quickly in case somebody wants to see it, and I may be asked to enter into explanations. All my explanations have gone out of me on to the paper, and that is enough for one trip. I hope you have enjoyed it; it was a lovely spot and the weather was kind.

A tonal composition with felt pen on tinted paper. White chalk is used at varying pressures, to bring light to the snow and sky.

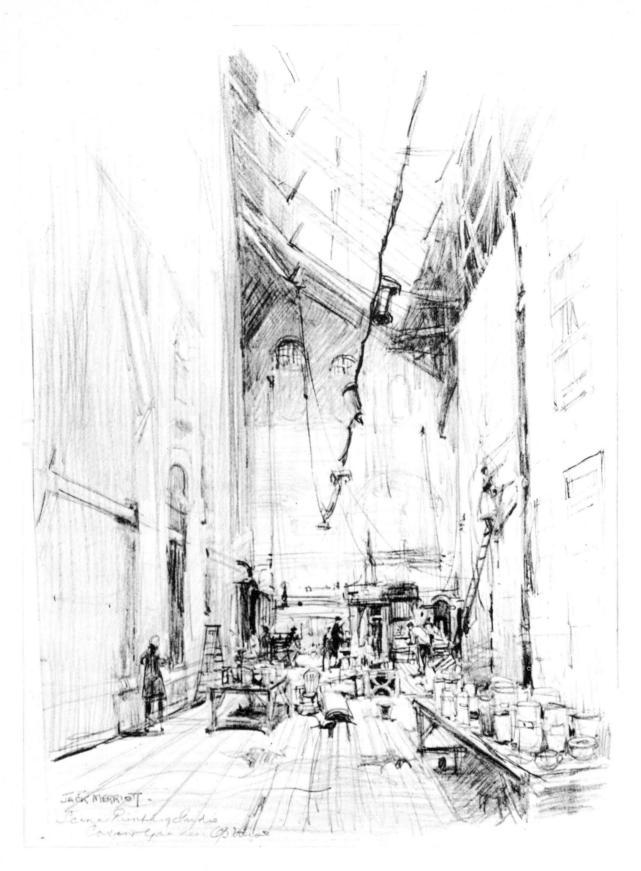

Scene Painting Studio, Covent Garden Theatre, pencil

Studio Workshop 5

BE SURE YOU KNOW THE FUNDAMENTALS OF PERSPECTIVE

Aerial. The lightening of tones and colours as they retire. Do not be misled by bright colours; make due allowance for the greying effect of atmosphere.

Linear. Lines which are horizontal in nature, like the courses of brickwork or the ridges of houses, when above the eye-level and going away from you, appear to slope downwards as they retire. Those below the eye-level appear to slope upwards.

Give as much time as possible to:

(*a*) Judging the apparent slope of lines in perspective with the aid of a mask.

(*b*) When you are out and attracted by a scene to paint select several different compositions in the manner of Fig. 25 and choose the one you like best for a finished work.

(*c*) Make many sketches in line of buildings from observation.

Make a few simple drawings, a house, bridge, boat, tree and so on, with the No. 2 brush and ultramarine blue. Then apply a wash of yellow ochre over the paper, and try adding various colours and tones whilst the original wash is wet. The different colours should blend with each other around the edges, but not be lost in each other. Some measure of control with the damp brush is necessary, and you will learn the relative quantity of water to pigment required to make this possible.

TEST-YOURSELF EXERCISES

1. Go out and make a drawing in pen and ink of a street scene where you are looking down the road, and introduce one or two figures. The position of the head and the feet should be right in relation to their background, a dot for head and another for feet connected by a line would do. Some doors and windows should be shown. It should not be too complicated. All lines must be watched in perspective.

2. Try a completed watercolour of a simple building composition (not necessarily the same as in Exercise 1), produced in the manner of my demonstration. Choose a view where you are looking aslant at the buildings, rather than facing them.

9 *Figures in Landscape*

In the last chapter we touched on the introduction of figures into landscape from a perspective point of view, especially in association with buildings, but of course we shall need to know something more about figures than this if they are to play their full part in the creation of a picture.

Figure painting, like portraiture, is a separate branch in itself, and as a general rule you will find that established artists specialize either in figure, portrait or landscape painting. Although they may have facility in handling all three, yet their forte lies in one particular branch according to their preference. Whereas in the past such great men as Rubens, Gainsborough and others were masters of all three, it appears to me that as time passes life becomes so full and so complicated that it is not long enough for us to study all that we should like. Therefore we find ourselves concentrating upon only one aspect of painting.

In this Course, stress is laid on landscape, so that we shall deal with figures just in so far as they may be found necessary for the improvement of landscapes. How frequently one sees landscapes ruined through lack of sufficient knowledge and experience in figure painting. Much-needed figures are either omitted entirely through timidity, or if painted appear wooden and lacking

(Left) At the Coronation of HM Queen Elizabeth II.

a b c d e

Fig. 28 Aids with figures in landscape. *Described in detail on pages 78—9.*

in life or movement, are too hard in tone or colour, are too large (a common error), are disproportionate in themselves (the head often too large), or in many ways do not belong to or form part of the landscape in which they appear. Men in boats are frequently too large and I am sure the boats would sink with such human cargoes!

Some pictures, such as street scenes, must have some human life visible. Figures help to lead the thoughts and interests, and also furnish a very valuable scale by which we recognize heights and distances. How uninspiring are those sketches, so familiar to us all, of streets as devoid of life as a mausoleum, not even a dog to mar the excessive tidiness of the dustless pavements. Who wants to live in such a deathlike, perpetual Sunday morning atmosphere? It is the life around us that we wish to enjoy. Life with its dust, its smoke, yes, and even its smells, and if we can suggest something of these we shall not have laboured in vain.

On the other hand, when I think of the rugged mountain fastnesses of Scotland, the open moorlands, the dark mysterious woods, and the wild tumultuous sea, I want to enjoy these alone. The surge of life is there in nature, all around me, and a human being or even an animal would sometimes seem to be a trespasser in that elemental domain where I stand alone and almost fear to move lest the spell be broken. A figure can accentuate the sense of loneliness in an open country road, but there are some subjects which the artist wants to enjoy absolutely alone, and which the viewer of his pictures can appreciate in a like sense of personal isolation.

Subjects that require some life interest will frequently come our way, and we cannot hope to avoid them, even if we should so wish. Actually the human interest in a picture is most exciting to paint, presenting us with all kinds of interesting problems, so it will be necessary for us to give some time to the study of figures and animals in the landscape. Just as we need to learn

j k l

<div style="text-align:center">

f g h i

</div>

only the fundamental principles of perspective, so is it not essential that we make an exhaustive study of the figure and its anatomy. We must have a sufficient feeling for the living creature to ensure that, however slightly or loosely it is suggested, what is indicated is correct.

It would help you a great deal if you could attend a local art school or art group to get some experience in sketching from the model, either nude or draped. When I was studying I was not permitted to work in the life class until I had been through the "Antique" stage (the study of those white plaster casts of ancient Greek masterpieces), but since we have already dealt with the question of form in earlier chapters, and you now have some experience and understanding of this three-dimensional quality by your study of still-life, there is no reason why you should not be able to tackle the human figure. It is naturally more difficult, but it is all a matter of building up experience by practice. If you can paint a pot with a good feeling for three dimensions, you can paint the trunk of a tree or a torso. The model, like the pot, is a solid object, and it is the manner in which the light falls upon it that makes us conscious of its solid nature.

We shall not be concerned with details such as features, hands, fingers, etc., but we are concerned with a solid living animal in space, with the light falling upon it from a given direction. By concentrating upon the lit shapes and those shapes seen in dark silhouette, and the placing of the feet, it is quite easy to suggest a figure, but what we suggest must be based upon truth, not only of form but of proportion and pose (or action).

PROPORTIONS OF THE HUMAN FIGURE

For the purposes of a rough scale, take the length of the head from the top of the hair to the bottom of the chin as a unit. This length, divided into the

<div style="text-align:center">

m n o

</div>

height of a human being, goes roughly seven times (Fig. 28, diagrams d and e). To increase the number of heads in the height would be to increase the feeling of dignity and the height of the individual. To have less than seven heads in the height would be to make the figure appear shorter. The width of the head goes roughly three times into the width of the shoulders. The length of legs is approximately half the height and the suspended arms extend about halfway down the upper leg. These are average proportions of the human species, and other proportions can be observed and remembered by watching people around you. You will notice how these proportions vary according to the particular characteristics of the individual.

Diagrams a, c, f and h in Fig. 28 are figures suggested with the least possible number of lines, something in the style of "matchstick" figures, but each line is essentially functional. Each consists of an oval for the head, and lines to indicate the position of spine, shoulders, legs, arms and feet. These functional figures are excellent for suggesting the pose and action, since they constitute the essential lines for indicating balance and movement. If you compare these with the brief half-tone sketches, diagrams b, d, g, and i, you will see how the former suggest, in the briefest possible way, proportion, pose and movement expressed in the latter. These last were constructed on the same essential lines. Diagrams a and b show a seated figure; diagrams c and d are standing erect; diagrams f and g are leaning forward; diagrams h and i are bending over.

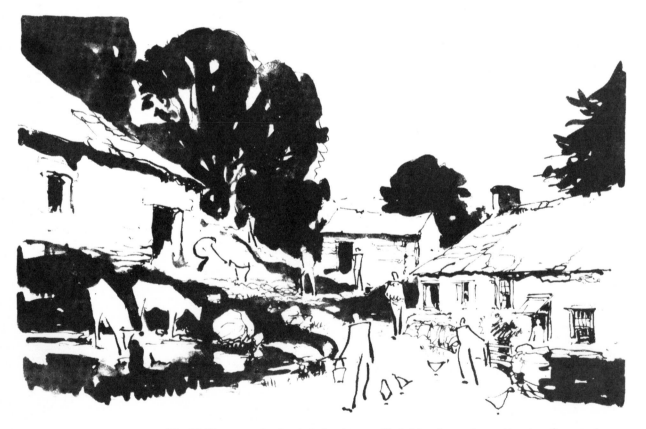

Fig. 29 Figures and animals in landscape. *Sketching from observation in a farmyard provides notes for later pictures.*

Let us now refer to the actual nude model. In order to get the pose or swing of a figure, it is important to note the curve of the centre line of the torso. If seen from the back this will be the spine, if from the front through the breast bone and navel. Then note the direction of the line drawn through the shoulders in relation to this. We must note carefully the relative positions of the salient points, i.e. the head, shoulders, hands, feet, knees, hips, pectoral markings and navel (diagram j, k, l). By the variation in the positions of these points in relation to each other, the whole pose is altered, so that if we are drawing from the model, the first thing to do is to fix these points in just the same way as we did when laying out the composition of the still-life group in Chapter 5. If these points are right, we can proceed to work to them and be sure that the pose will be right.

You should get into the way of suggesting figures, in the brief manner of diagrams $a-l$, either in the nude or clothed. You can get ideas of a variety of positions, poses and gestures from the people around you, making sure that you get the proportions right and that a fair suggestion of the pose is expressed. After some practice you will find that you are able to indicate several figures grouped together, as in diagrams m, n, o. These examples are merely blotted in with an appreciation of form, proportion and pose.

INTRODUCING FIGURES INTO LANDSCAPE

The next step is to introduce figures into natural surroundings. Let us consider a farm scene, for example. This would be very lifeless without a figure or animal and would lose a lot of its attraction and character. Suppose we make a drawing of the farmyard, Fig. 29, in outline. Before painting in the dark masses, or colour and tone, we wish to introduce one or two figures and animals. There are a few cows, chickens, and a dog around, and a farmworker is moving about doing his various jobs. It is useless to try to make a detailed study of each of these, since they are continually on the move, and if we could it would only result in static creatures, incapable of movement and probably badly placed. As soon as we get an opportunity, wherever the farmworker appears, make a rapid note of where his head and feet are placed according to the trees or buildings behind him, e.g. his head on a level with the point of a roof and his feet just below the shadow across the pathway and near the low wall. This fixes his height and where he is standing, and we add one or two functional lines, as already explained, to fix the proportion and pose or action. By this time he will be somewhere else, so we do the same again and again. In the same way we can deal with the cows, hens, and any other animals which may appear, thus establishing various positions for the life interest, true in proportion, pose and action, from which we can choose just those we require, and eliminate the rest. With these essentials, we can now take time to observe the farmworker and animals more carefully and more information in the brief manner shown in Fig. 29.

a

In my drawing, Fig. 29, you will see the ground is irregular and rises as it goes away. It would be difficult to draw the figures the correct size, i.e. correct in proportion and perspective, had we not taken the precaution to fix the position of head and feet. This can be done while a man is walking, and after some practice in drawing these functional figures you will be able to seize on the essential lines before he is out of sight; memory and later observation will enable you to fill in what other details are necessary.

When several figures are standing on level ground and we are on the same eye-level, the heads will appear roughly on the same line and the position of the feet explains whether they are near or distant. Fig. 30, diagram *a*, shows five functional figures in these circumstances. If I climb up a few feet and look down on five other people, the distant figures rise with me, above the heads of the nearer ones (diagram *b*). If I lie down, the feet of near and distant figures are almost on a level, whereas the heads appear lower and lower as they recede (diagram *c*). I have shown in diagram *d* a group of these functional figures, correct in proportion to the boats and with a fair idea of their pose and action. They are fishermen, packing their nets into their sardine boats at Tossa de Mar, Spain. Such notes as this and Diagram *e* are good practice for placing and composing figures, besides providing excellent records for future reference.

b

I have made many quick notes in this manner in pencil, ink, and water-colour, and a great many of these have provided most useful motifs for later pictures. They also serve to remind me of many happy experiences in my life, helping to re-create in my mind the emotions I felt at the time.

A selection of the more important sketches is included in this chapter. These show how I made notes of Queen Elizabeth's Coronation in Westminster Abbey for a series of pictures for the *Sphere* magazine, the production of a play in the B.B.C. Television Studios, and Grand Opera from the auditorium, stage and roof of Covent Garden Opera House. You will see how useful it is to cultivate this method of making rapid sketch notes of people in action.

Apart from painting figures and animals for their own sakes, we must consider what other reasons we have for their inclusion in a landscape. These are as follows:

1. To provide a scale of proportion and enable the observer to assess the size of surrounding objects.

2. To create balance by weight of tone, colour or interest.

3. To attract attention to themselves and that part of the picture in which they are placed.

c

Fig. 30 Figures.

c >

d

e

4. To lead the vision, thought and imagination of the observer in that direction in which they are moving or looking.

5. To introduce life, movement, colour and companionship, and local character, dress and occupation.

These various considerations are served according to the placing of the figures in my picture "Farm Below Polperro" (Plate XII). Let me explain my approach in this charcoal line and wash drawing of the Cornish view near my studio.

I was chiefly attracted by the placing of the farm within the patchwork fields and distant church tower and hills. I observed also a ploughman at work with his team on the far side of the field, and realizing that he would make several journeys up in my direction, I decided that this would provide just the amount of rural life and action which I needed. The two foreground fields would be rather blank without figures, so I sketched in the group when it was in a position where it would relieve this blankness, a little to the right of centre. Also the group should be moving away from the observer, so that besides attracting attention to itself, in harmony with the rural character of the scene, it would lead the vision, thought, and imagination down the plough ruts direct to the centre of interest, the farm.

The five purposes listed above have therefore all been served by the introduction of the horses and plough. Can you imagine the group placed over in the left-hand corner of the foreground, coming towards you? This would overbalance the composition in weight and interest and, after it had attracted interest to itself, one would be led straight out of the picture without having noticed the farm and church.

ANIMALS IN LANDSCAPE

Animals are particularly difficult to record as they always seem to be on the move. If you pause to sketch a cow lying down, it seems to move as soon as you begin to sketch. But you must take every opportunity to sketch cows, sheep and horses, as well as the poultry on the farm, for it is such good practice in learning more of their proportions.

For animal action studies, use a large sketchbook with pen, pencil or brush. It's a good idea to have several sketches going together. A few lines here and there, and then back to earlier drawings when positions are repeated, is the way to go about it. In this way, an afternoon at the zoo can be well worth while, if you seek the unusual. I have spent many happy hours in farmyards, and by sheepfolds, as my sketches here illustrate.

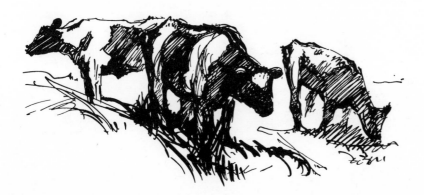

Studio Workshop 6

FIGURES AND ANIMALS IN LANDSCAPE

Get the habit of drawing functional figures in all kinds of attitudes, later developing these through study of the figure and/or costume, into the briefest notes of persons and animals, first with the pencil and then the small brush with burnt umber or ivory black, and finally in full colour. You will gradually acquire facility in the suggestion of living creatures which will be convincingly alive and moving.

Figures should be grouped together when possible, some in front obscuring parts of those behind. This is true to Nature. Avoid a series of similar-sized figures all equally spaced from one another. This gives an unnatural and spotty or cut-up effect.

Figures can be introduced to attract attention where desired. If they are badly placed, well away from the centre of interest, or are moving or looking away from it, they will tend rather to distract attention.

When about to include a figure in your picture, make a note before anything else where the head and the feet are placed compared with the background, and then by functional lines fix the proportions and pose or action.

OBSERVATION EXERCISE

Whenever you find yourself among people, notice where the heads and feet occur in relation to each other and to the surroundings, in the street, in the train (while strap-hanging), in the shops and public buildings, and particularly note what happens when you are going up or down hill, or on uneven ground. Compare the height of people with adjacent objects and buildings: a near person with a distant building behind him and distant figures standing alongside tall buildings, and so on.

1. If you are unable to study the model at an art school or group, persuade members of your family to sit for you and make brief drawings of them in the manner of Fig. 28, with stress on proportion, pose and action. Make

similar drawings of any domestic animals available. Failing these, sit before a large mirror and use yourself as your model.

2. Practise drawing with pencil and brush these functional figures by translating figures out of magazines or newspapers, both individually and in groups and crowds, concentrating all the time on proportion and pose.

3. Make a rough sketch of the room in which you are sitting, be it studio or kitchen, and then get a friend to stand for a few minutes in various different places and attitudes, so that you can draw several of these functional figures in relation to the different objects in the room.

TEST-YOURSELF EXERCISES

1. Prepare a sheet of drawing paper containing about twelve functional figures (an oval for the head and a few lines for proportion and pose), each being taken direct from life.

True proportion and variety of pose should be looked for here. You will no doubt need to make many sketchbook drawings before you feel satisfied enough to transfer some of these to the final paper.

2. On another sheet, in pencil or ink, prepare four groups of functional figures and/or animals. Introduce as much action as you can.

3. On a third sheet, and with the No. 2 brush and burnt umber, translate about six of the above drawings into brief half-tone sketches as in Fig. 28*b*, *d* and *h*, keeping to the proportions and pose or action you have set and now suggesting the sense of form.

4. On a sheet of the watercolour paper, make a watercolour sketch of a farmyard, including trees and buildings, and also two figures and a few animals. I would like you to make the figures and animals the chief interest of the picture, but it should be judged on the accuracy of proportion, the placing of head and feet, in relation to the surroundings.

5. On another sheet of watercolour paper, make a sketch in full colour of a country landscape, introducing one or two figures and/or animals. In this the life interest must be subordinate to the scene.

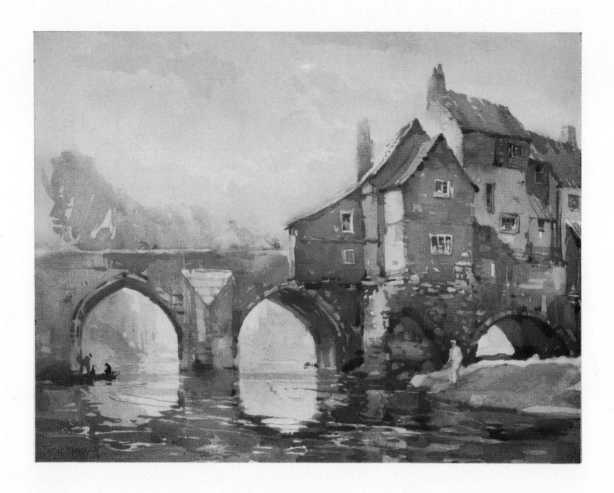

ELVET BRIDGE, DURHAM (FINISHED PAINTING)
Watercolour 18 × 23 in.

*A picture is often marred in its final stage by too
much attention to detail. Jack Merriott explains
that it is by suggesting the interesting features,
rather than by detailing them, that he hopes to
lead the thoughts of the beholder of the picture and
thus help him to experience the emotions that he
himself enjoyed. "I must not say too much, just
briefly explain textures, airy clouds, stone and
brickwork, mosses and stains on the ancient
bridge, and the various shapes and sizes of the
windows, warped by age." (Chapter 8.)*

Plate XI

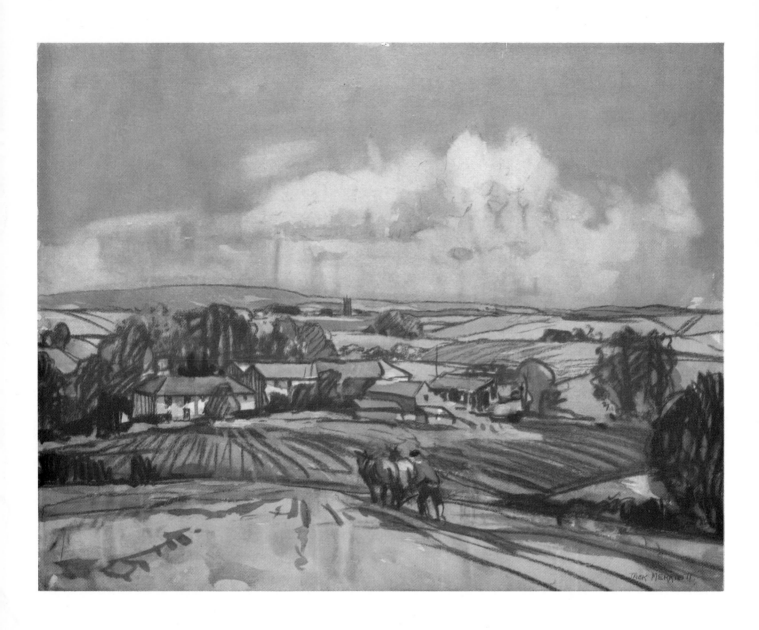

FARM BELOW POLPERRO, CORNWALL
Charcoal line and wash 15 × 22 in.

*Sometimes figures can be helpful in a landscape.
In this, the two foreground fields would have been
empty without them. Note that the ploughman and
his team of horses are moving away from the
observer toward the interest of the farm buildings,
and creating a balance with them.*

Plate XII

10 *Interpretation of Light*

We have now reached the stage when we can more deeply consider our individual reactions to things around us, particularly the transient effects of light and its influence on the form of the components of landscape. Mention was made of the interpretation of visual impressions in the first chapter, and I explained what takes place within the mind when we are moved to express ourselves in painting. By way of example, I described my own reactions which led up to the painting of Porthleven (Plate I), and indicated how such a view may be seen and expressed in various ways according to how one feels and what one wishes to say about it.

We all experience these varying emotions, and I hope that you have now learnt to analyse your feelings and organize your thoughts in this way. It is these personal reactions and their interpretation which constitute the whole essence of painting and, for that matter, of any of the arts, and it is by truthful and sincere fidelity to our own personal feelings and the manner of their expression that the true artist is recognized. His stature may be gauged according to the nobility of his thoughts, and by the measure of his attainment of those qualities referred to in Chapter 5.

We all know that unpleasant feeling of frustration when we experience

these emotions but are unable to interpret them through the lack of a sufficiently extensive vocabulary. We have done quite a lot of spadework in the way of practical exercises and therefore we should find that we are a little more articulate than we were. Let us then investigate a little more deeply some of the more subtle manifestations of Nature which stir the emotions and then see how they can be dealt with.

So many people seem to think that there is little opportunity for originality and imagination, or even a need for any particular mental exertion in landscape painting, and that all one has to do is to sit down comfortably in a sunny corner and paint just what one sees. I have even heard some express surprise that two artists, sitting together and painting the same view, should produce two very different pictures, and they seek to find an explanation in some literal inaccuracies in the drawing. How could they produce similar pictures? They are two different entities with different thoughts and deriving pleasure from different ideas.

Imagine Turner, Brangwyn and Sargent together making sketches of a schooner moving slowly out of the estuary in the morning light. With memories of "The Fighting Téméraire" can you not imagine Turner subordinating detail in the ship, but using its grey silhouette to accentuate the flood of golden light? Brangwyn would love to dwell upon the height and majesty of those tall masts and shrouds, and the massive sails billowing out with the breeze. He would use them to produce a powerful and noble design. Sargent, on the other hand, would thrill us with the boldness of those huge blobs of water colour, so direct and perfect in tone and tint, producing a scene of movement, colour and space. These would be three very different interpretations of the same scene, yet each one stressing a specific truth of beauty according to the individual vision.

Effects of Nature, particularly those of light, exert a considerable influence upon our mood, emotions and feelings. Our visual experiences are entirely dependent upon light and there are different ways in which this can be expressed. Turner spent most of his life trying to get this quality of light into his pictures, sometimes opposing the deepest darks to the highest lights in strongest contrast, and gradually reducing the darks until, in his later life, darks were almost eliminated and his huge canvases became somewhat empty. He was never satisfied but I do feel that he got as near as anybody, before or since, to the expression of pure light.

INTERPRETATION OF SKIES

Among some of the most beautiful effects of Nature are those seen in skies, and the results of cloud shadows. All my life I have taken the greatest delight in watching the sky, and making many studies of the different cloud forms. At times, when I have felt hemmed in and weighed down with nameless worries, and with an overpowering desire to escape, I have turned my eyes

to the sky. Looking between those brilliant fields of white clouds into the vast realm of blue infinity, matters of earth have become very small and insignificant. Skies offer a continual source of study and contain endless variety, colour and movement. They are not easy, but when painting landscape a good sky is so frequently needed that we must give this aspect of our studies special attention. I say "frequently needed," not "always," for a sky can be so intriguing and well painted in its complicated forms that the landscape is lost sight of. If you wish to stress the beauty of the landscape and draw attention to interesting details there, then simplify the sky to avoid any competition. On the other hand, if the sky is your chief interest, simplify the landscape.

Skies must be consistent with the landscape to which they belong. If you wanted to suggest an effect of wind, you would not depict unruffled trees in a placid landscape with a blustery windswept sky. Nor would you paint a heavily clouded sky over an entirely sunny landscape except in unusual circumstances. An example of such exceptional conditions would be a heavy storm cloud rising from the distance like a huge pall into a clear blue sky from which the sun is beating down at an altitude outside the picture plane, and lighting up the foreground landscape. A similar effect is illustrated in Plate XIV, "The Storm Cloud," which was painted on the spot at Walberswick. Let me describe how I painted it.

THE STORM CLOUD

Soon after I had settled down to the enjoyment of a bright sunny afternoon, and prepared my materials for a sketch of the river, I became aware of the appearance of the dazzling white puffy crest of a huge cumulo-nimbus cloud rising from the horizon, and approaching me rapidly. I knew this would be a soaker, but as I was standing by an upturned boat, I decided to rely upon this for shelter, and immediately turned my attention to the cloud, painting the dark blue of the upper sky (ultramarine blue, light red, and black), down to the edge of the cloud, using it to get the form, then softening the edge into a wash of yellow ochre and light red for the cloud itself, and introducing more of the above dark blue with the addition of a little crimson alizarin for modelling the cloud and for the dark heavy base, down on to the horizon. The distance was touched in darker under the shade of the cloud, and then the colour and tone changed to viridian, cadmium yellow and light red for the sunlit grass and light blue-grey for the water, allowing for the reflection of the cloud.

I dared not wait another moment, for one spot of rain on the washes would have ruined the whole thing, so I shoved everything under the boat and crawled in after them, just in time, for there was a veritable cloudburst, thunder and lightning added to the excitement of the moment. In half an hour all was peace again as the storm retreated grumbling out to sea. The

paper quickly dried and I was able to put in the necessary details, and choose my cloud shadows on the foreground from passing clouds.

CLOUD FORMS

It is quite unnecessary to remember all the names of the many different cloud forms, but I feel you should be familiar with the main types. I have selected the following watercolours to illustrate them.

Fig. 31. *Cirrus.* These are the highest clouds composed of ice particles seen in wisps (mares'-tails, etc.) associated with high winds. Altitude 20,000– 30,000 feet in Britain.

Fig. 32. *Cumulus.* These are fine-weather clouds with puffy white tops. Their flat bases average 1600 feet altitude. They sometimes build up into the large cumulo-nimbus or storm cloud, base 1600 feet, with a crest up to the height of the cirrus. In fact they are sometimes associated with the cirrus in anvil form.

Fig. 33. *Alto-stratus.* Associated with alto-cumulus. The alto-stratus are flat layers of cloud, seen usually in the evening, altitude 6,500 feet.

Fig. 34. *Alto-cumulus.* Altitude 6,500 feet, sometimes referred to as the mackerel sky. Serried rows of small cumulus clouds.

Fig. 35. *Nimbus.* This is the "all-over" cloud, low down to ground-level, dull and rainy. This sketch shows a fracto-nimbus, which is a ragged cloud of bad weather.

I find the cumulus clouds most interesting, with their dark bases, throwing their separate shadows over the landscape, and also at times the shadow of one falling upon another. When painting these clouds, remember they are just visible atmosphere, soft and ethereal, and their edges must be carefully treated with every variety of softness and firmness. Yet they have volume, and their flattened bases, receding into the distance, are subject to the laws of perspective. It will help you if you think of a series of boxes suspended in the sky, each receiving its light from above, with shaded bases, and casting their shadows on the earth.

SPECIAL EFFECTS (FIG. 36)

One afternoon I went down to the banks of Loch Awe in Scotland during some very showery weather, and I saw a most intriguing effect over the mountain Ben Cruachan. There were two layers of cumulus clouds, the upper layer verging on cumulo-nimbus, being heavier in form and containing rain, radiating the most brilliant light. The lower layer comprised a series of small clouds floating between me and the mountain, and about half the altitude of the latter. These again were brilliant in their whiteness, and yet were sufficiently dense to cast their shadows on the mountain-side, and I noticed that as they passed beyond and away from the proximity of the

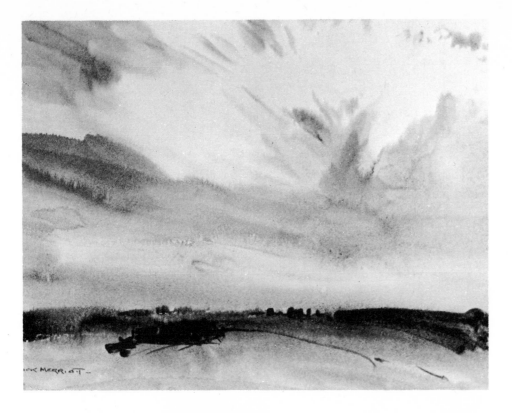

Fig. 31 Cirrus clouds.

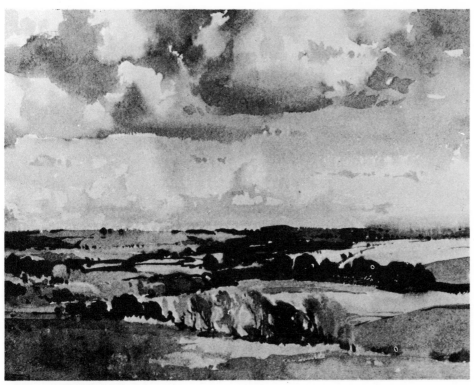

Fig. 32 Cumulus clouds.

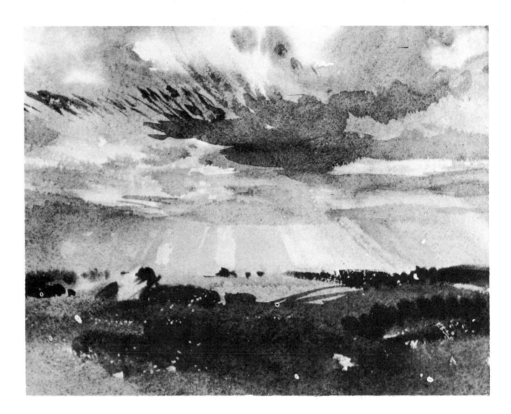

Fig. 33 Alto-stratus clouds.

Fig. 34 Alto-cumulus clouds.

Fig. 35 Nimbus clouds.

Fig. 36 Unusual cloud effect.

mountain their white mistiness gradually became evanescent, at last disappearing altogether. I knew this would be difficult to sketch, but I felt I must have a shot.

SUNSET AND SUNRISE

These are effects that are very lovely in themselves but very difficult to paint without making them look "pretty," because of their bright colour. As when painting the waves, the effect is very brief and therefore one must observe and remember as much as possible before painting. The last sunset I painted was in Scotland. There appeared to be the prospect of a good sunset, so I went some distance up the mountain and reckoned I should have about twenty minutes before the main effect, providing some low alto-stratus clouds did not rob me of it. I made a start with background and foreground, leaving sky and loch. The moment came, and I went straight for it, using yellow ochre, alizarin crimson, cadmium red, cadmium yellow, ultramarine blue, and viridian, painting the sky and loch together, and making full use of the greys of the clouds seen in silhouette to throw up the light and colour of the streaks of red and gold.

Remember the thing of first importance is the "light." All pigment you put on is darker than white paper, so you must be very careful in judging the quantity of colour so that it will not reduce the light. The effect lasted about seven minutes before the low clouds ruined it, but it was very exciting while it lasted.

From the few pictures one sees nowadays of such effects it would seem that artists are inclined to avoid painting them. Is it because they *are* pretty? Is it for the same reason that they avoid bluebells, flower gardens and thatched cottages? I confess this is so with me. Prettiness is a quality which should be avoided — rather cultivate the more dignified quality of beauty. Even this seems to be taboo in some art circles today, but whether it is in or out of vogue I contend that beautiful things in this world were given to us for our edification and enjoyment, and if we exult in something we have seen, and can pass on our happy emotions for the joy of others, this is something worth doing. A sunrise or sunset is noble and inspiring. A bluebell wood at the advent of spring, with its heavy odour, is sweet to the eye and the nostrils. If we cannot paint such things without making our efforts "pretty-pretty," then surely the fault is ours and not that of the subject. What an excellent theme for the abstract painter: "the scent of bluebells"!

MEMORY

You will by now realize that all these transitory effects make a big demand on the memory and call for speed in handling, which will come only by continual practice and applied effort.

To make a successful memory sketch, one must first get clearly into the conscious mind, from remembered facts, a vision of the actual scene, and then recall and enter into the same emotional mood experienced at the time. In such circumstances there is little difference between painting the scene from memory and doing it on the spot, except that, given a sufficiently good memory, you are able to work under the best conditions in your own home, and, to some extent, at your own speed.

Memory must play a dominant part in our painting, and the more we can cultivate this the better it will be. At all times when you are sketching, you first look at your subject and then you paint a few touches on your paper. This is repeated again and again until the sketch is completed. Each time you avert your eyes from subject to paper you are recording what you remember. These periods of observation are often momentary. Try to extend the periods of both observation and execution, if only by a little each time. This will extend your capacity for remembering what you have seen.

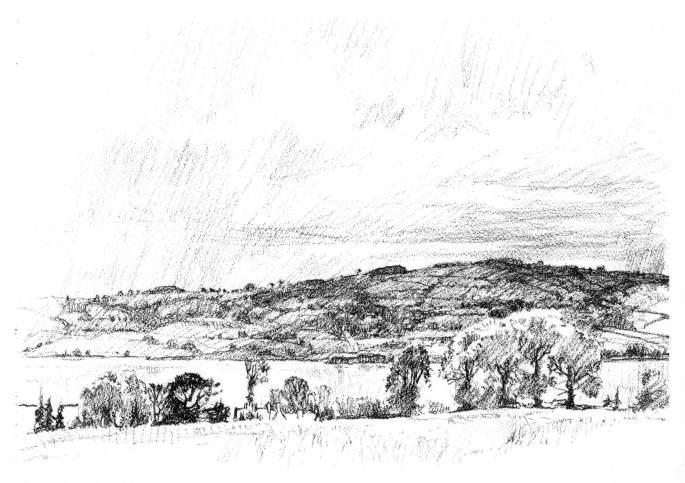

Wet evening, River Teign.

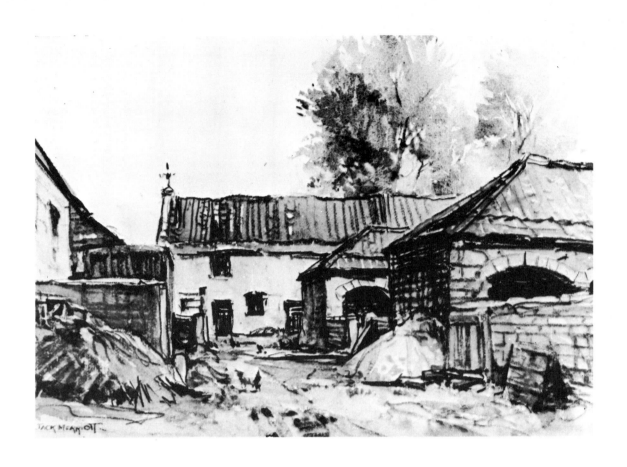

The Farmyard
This is a charcol line drawing, washed with watercolour. Most of the darker tone values have been obtained with charcoal, which was fixed before the washes were applied. Observe how these washes have been loosely applied and somewhat varied in strength to improve the tonal result.

Studio Workshop 7

IMPROVING OBSERVATION AND VISUAL MEMORY

Nature's most dramatic effects are always brief and to interpret them with watercolour the memory must be long. It will pay you to cultivate it.

When you are striving for a particular effect it will help to observe all details connected with it, and especially other subsidiary effects which are influenced by and must be consistent with, the main effect. For example, in working on a particular cloud effect in the sky, notice the influence of it upon the light and shade of the landscape beneath it. Your visual memory can be assisted by the inquiring mind studying cause and effect. For example, when the sun is in a certain position, you must notice how the shadows of objects are distorted according to the position or shape of the surfaces upon which they fall.

AIDING THE MEMORY

You might start off by concentrating your attention on simple objects in your room, or go out to the shed or outhouse and look at an interesting group down in the corner, or on the window ledge. You know the party game in which a number of objects are brought in on a tray covered over with a sheet; when the sheet is removed you are allowed a few minutes to look at the objects and commit them to memory before writing down as many as you can remember. Painting is a similar game, except that you paint your impressions. Allow yourself ample time to absorb the subject. From simple things, gradually tackle the more difficult ones, such as somebody sitting reading or working in the garden, until you can eventually try your hand at recording some of those impressions you have been looking at concerned with effects of light upon objects in the landscape, and the special effects of changing time or season to be seen in the sky.

TEST-YOURSELF EXERCISES

Sky painting

Begin to win your own battle with sky painting by making numerous studies
on cheap drawing paper of at least quarter imperial (11 x 15 in.) size. Paint
many skies to this size, without the use of lines, direct from Nature, either
from your window or out of doors. It is best to include a narrow strip of the
landscape that meets the sky in its correct tone, for always there must be the
right relationship of tone in both sky and earth. It is suggested that you
select your sky studies at different times of day and season. For example:
 (*a*) Clear blue sky, early summer morning, with cirrus clouds.
 (*b*) Cumulus clouds in a deep blue mid-day summer sky.
 (*c*) Cumulus clouds by moonlight over water.
 (*d*) Alto-stratus and alto-cumulus clouds at sunset, summer.
 (*e*) Cumulo-nimbus cloud, and cumulus clouds, autumn afternoon.
 (*f*) Nimbus and fracto-nimbus, winter morning.

INTERPRETATION OF LIGHT

Find a suitable window in your house, shed or workshop, where the light
shines through upon an interesting group of objects. Now make a number of
sketches as follows:
 1. First a picture of the window and the group, with your attention con-
centrated on the *light* from the window. Details of the window frame, and of
the objects in the group will be subordinated, softened or sharpened as is
necessary in order to express the *light coming through the window.*
 2. Now paint a picture of the same window, but in this case the window
and group to be subordinated to the interest of the view seen through the
window. Be sure you judge the correct tonal value for the inside wall and
window frame, compared with that of the view that can be seen through it.
 3. On a rainy day, find a subject where you can interpret the light reflected
on the wet pavements. Start with a loose light wash all over the paper, and
while it is still wet, begin to indicate buildings and other objects, and their
reflections on the wet surfaces.
 4. On a foggy day, observe how the trees go quickly out of focus into the
mist. Try your hand at painting this effect.

11 *Interpretation of Water*

SEA AND STORM

At the time of writing this in my private studio, high above the harbour entrance and facing out to sea, we have been experiencing some very rough weather. Dawn was very sluggish in making its appearance this morning. I felt depressed and unsettled, not knowing which task to tackle first and lacking enthusiasm for any. The rain and spume beat against the windows, and the wind whistled and moaned through every crevice; the very house vibrated with the shock of each gust of the wind, which was blowing a gale, and the baulks below me, sealing off the inner harbour from the rough sea to protect the craft within, screeched and bumped at the pressure of each surge.

I went to the window, washed clear with a sheet of water as the storm raged. Low scudding clouds raced across an inky grey sky and immense waves in long blue-black ridges on the horizon foamed at their edges here and there as they approached, curling over and throwing up bursts of froth in their headlong career, eventually rising in a wall of grey-green water to dash themselves against the black rocks, and, meeting their unyielding resistance, venting their unbridled fury in a bursting cascade of scintillating light. "Oh, wild

Fig. 37 Charcoal impression. *Charcoal is excellent for rapid tonal sketching, particularly of scenes involving movement. The tone values can be so quickly stated or changed to your requirement by the rub of a fingertip, or a lifting with soft eraser. For water in movement a good quick impression of the lights and darks makes subsequent painting easier. A few soft pastels can achieve a similar result in colour.*

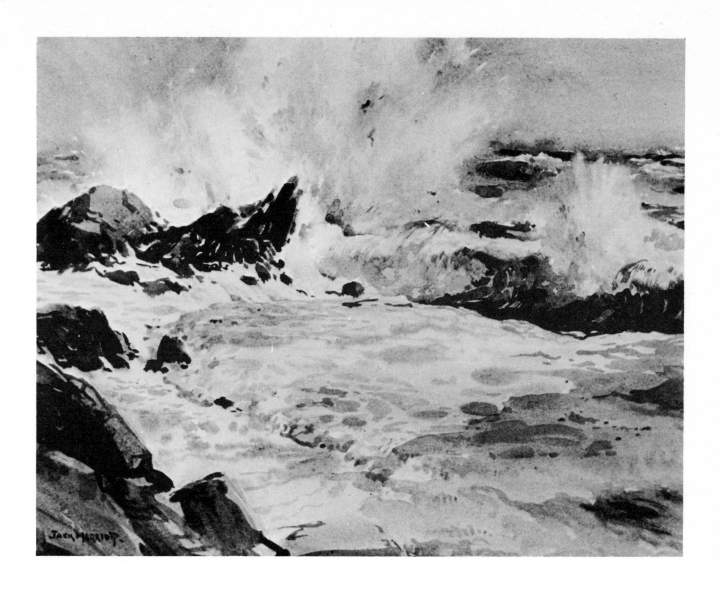

Fig. 38 Rough sea (Finished painting). *Jack Merriott explains the stages of painting this masterly watercolour in Chapter 11. The skill and technique required to paint a stormy sea will only come from continuous and close observation of these effects direct from nature and as they occur. His analysis of this work will help you along the difficult road to success with seascapes.*

west wind," that I should be witness of such majestic ferocity! My mood had changed. I was excited, thrilled, I must set to work at once, everything must wait until I had tried to express this.

PAINTING A ROUGH SEA OFF POLPERRO (FIGS. 37 and 38)

I take over to the window a quarter imperial sheet of drawing paper and a piece of charcoal. There is no time to make myself comfortable. I prop the board up on an old sideboard there and squeeze myself into the corner, rather awkwardly, to get a full view of the rough sea raging outside. Before attempting to sketch, I watch, waiting for the mammoth wave. Gradually I absorb the scene and when a large wave breaks over the rocks, I immediately turn my attention to other parts of the scene, to see what is happening to the waves just behind it. I also note how the stretch of water in front of it is yellowish with churned-up froth, flecked here and there with gaps of dark water.

I make a quick charcoal impression of the composition (Fig. 37), setting out to describe the huge wave dashing against the rocks, and the resultant swirl of water around them. My quick sketch fixes a tonal scale for the composition, and serves to concentrate my attention to that area of the water I need for the picture.

Now I bring over to the window a half sheet of watercolour paper, colour box, bowl of water, and three brushes, and await poised for action, for this is to be a quick painting to get the required effect.

Again I look at the dark tone of the distant rollers, and as quickly turn my attention to the wet reflecting surface of the rocks bottom left, and make a mental impression of their relative tones. Nobody is out in such tempestuous conditions and the only visible life is a cormorant riding just above the smoking waves and a seagull, gliding into the teeth of the gale, suddenly and without any apparent movement of its wings, rises absolutely vertically at incredible speed. My attention reverts to the waves beyond the peaks, and there I espy the giant I have been waiting for. Fifteen minutes I have been observing, thinking and planning so that, at the moment this great wave breaks, I shall be ready for it and know what I am going to do.

I mix ultramarine blue, light red and ivory black in a dark wash, and start immediately to put in the sky, down to the horizon on the left, and then I look again, ready and alert. The living mass of water is close to the rocks, its glistening crest curling over and throwing a shade on its ample breast as it hurls itself to disruption, shooting out in white jets of sparkling spray an avalanche of foam. I have seen the spectacle and the picture must now be in my mind.

With the No. 4 brush dipped into the sky wash, I rapidly draw in the shape of the breaking wave, pick up the No. 9 brush and with the same wash fill in the rest of the sky to the right up to this line. Then I dip into some

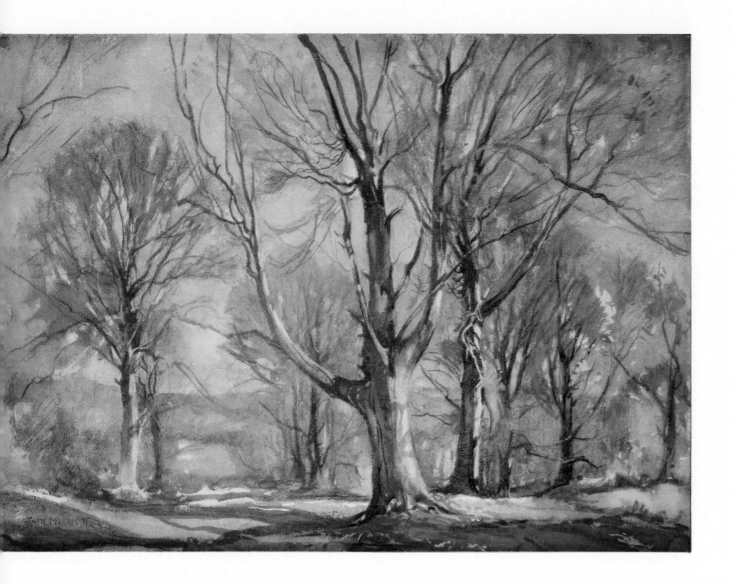

THE BEECH WOOD
Watercolour 22 × 30 in.

It is the well-considered lighting effect in this picture, and the faithful portrayal of the form of these magnificent beech trees in a manner without too much attention to detail, that provides the atmospheric quality of the painting. A comprehensive description of the method used will be found in the final pages of the book.

Plate XIII

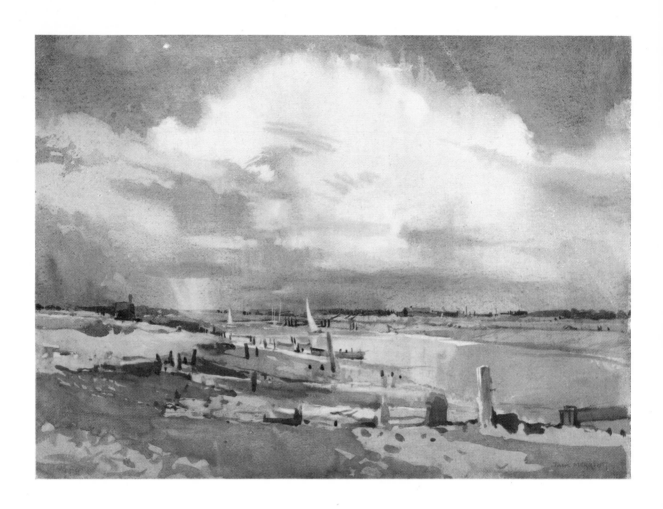

THE STORM CLOUD
Watercolour 15 × 22 in.

Skies must be consistent with the landscape to which they belong. A blustery windswept sky demands ruffled trees; a heavily clouded sky will cast an effect over the landscape beneath it. This study is an example of exceptional conditions, with a heavy storm cloud rising from the distance, like a huge pall, into a clear blue sky from which the sun is beating down at an altitude outside the picture plane and lighting up the foreground landscape. (Chapter 10.)

Plate XIV

strong ultramarine blue, burnt sienna and a touch of alizarin crimson and
paint the rocky promontory, watching carefully the tonal contrast and
leaving spaces for the channels of foam from the earlier wave. I next
complete the outline of the main wave by putting in the dark horizon and
distant rollers with their foamy crests, continuing down to the spumy yellow-
ish surface in front, thus leaving the shape of my breaking wave as a patch of
white paper. I wash out my No. 9 brush and, whilst damp, soften out some
of the edges of the spray and take out lightly a few of the scudding clouds
from the still wet sky wash.

Next, with ultramarine blue, viridian and light red in a very delicate wash,
I model the form of the white cascade, leaving white paper for the highest
brilliance. The main effect is finished. Other effects will repeat themselves
and may be painted a little more leisurely — the sombre foreground rocks
and the dark ridge of an advancing wave. In the immediate foreground, paint-
ing wet into wet, I paint the yellowish froth flecked with green and the grey-
green gaps of darker water.

I calculate that the painting of this, apart from a little touching up after-
wards, took me just about the same time as the period devoted to preliminary
thought and planning, about fifteen minutes. Such effects can only be
secured quickly. It will be a success or a failure, but it will certainly be the
latter if, without thought and planning, we get straight down to painting,
calmly trying to paint everything we see before us. We must feel it, see it,
and remember it.

Fig. 38 is a monochrome reproduction of this sketch, painted exactly as I
have described.

*Marine painting is very much a specialized form of landscape painting. It
requires a great deal of intimate study of the sea in all weather conditions,
and of course of boats and ships. The artist needs to have a real feeling for
the sea if he is to be successful in portraying its many moods and movement.
In the end, success will come only from constant observation and continual
sketching.*

*A number of Jack Merriott's vigorous sketches in line, and more reproduc-
tions of his marine watercolours have been included in this chapter, to arouse
your enthusiasm for painting seascapes. You will see how he gathered illustra-
tive material, thereby building up a store of experience for later paintings.*

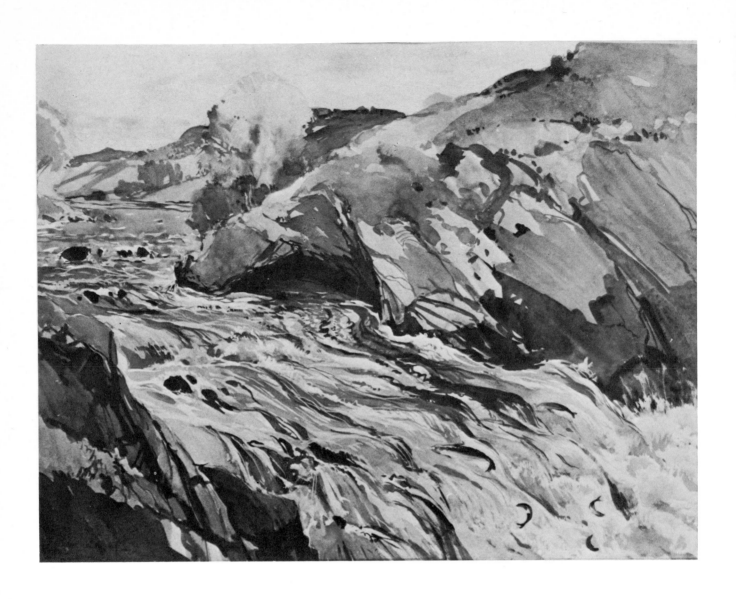

Fig. 39 Salmon leaping. *It can be said that the brave and persistent endeavour shown by the salmon to swim, as it were, uphill to get to its spawning ground, matches the qualities required on the part of a successful watercolourist. Many pencil studies were made for this picture before the onslaught with paint. These sketches decided how best to depict the water as it rushed from different levels, and how the light affected the tone and colour of it. These were trials for the best approach, much the same way as the salmon instinctively searches the route upwards.*

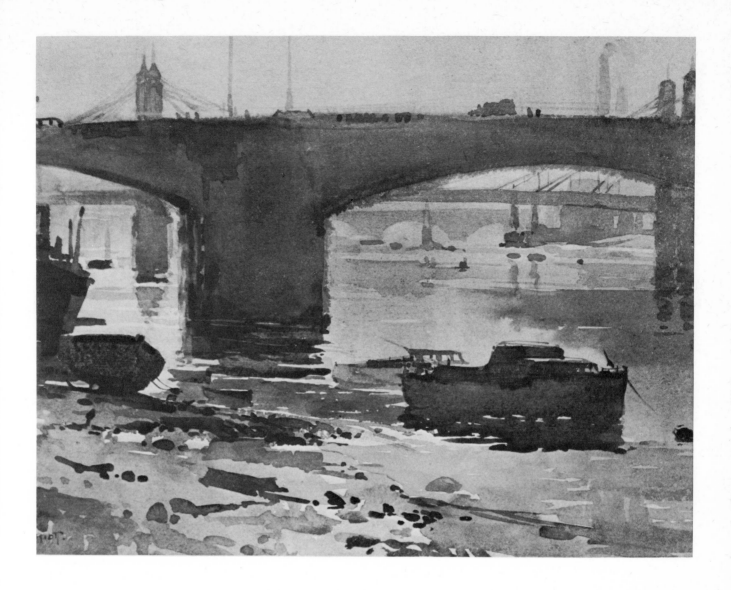

Fig. 40 River Thames at Chelsea. *Looking into
the source of light throws objects seen before it
into silhouette, so the first wash must be of a
tone and tint so judged as to form a backing for
this effect. In later stages, stronger tones in well
drawn simple washes are overlaid for boats and
bridges. The result is roughly, a three-tone
picture of light, middle and dark values, painted
in that order.*

By way of contrast, I think of a still morning on the bank of London's river at Chelsea Reach (Fig. 40). Through the arches of Chelsea bridge I can see two other Thames bridges carrying the incessant traffic back and forth. The rear lighting from the morning sky echoes in the river beneath it. I note that the reflections of the distant bridge are less sharp in the water than those of the nearest buttress, which mingle with the dark reflections around the boats to the right.

Parts of the muddy foreshore are well lit by the morning sun, against which the litter of stones and tidal flotsam stand out in their darks. I fix into my mind that the effect of painting into the light makes most objects seen before it somewhat dark silhouettes. I must be subtle with the recording of these darks, for as the various bridges recede into the distance the tonal value becomes less dark.

I concentrate my thoughts on what will be the tonal value and colour of the first wash to my picture, that will form a backing for the effect I am trying to create. In later stages, stronger tones in well drawn simple washes will be overlaid when the time is right to paint the bridges and the boats.

I begin by flooding the left centre of my sketch with a wash of yellow ochre with a touch of light red, increasing the latter at the bottom of the sheet where the light on the foreshore can be seen. Very quickly, and while this is wet, I paint in a wash of ultramarine blue with light red on either side of the first wash so that the one runs into the other. I take advantage of the wetness of this first covering wash to introduce into it a cooler blue-grey for the distance between sky and water, and to make something of the reflections in the river to the extreme right. Also I begin to set up the darker tones and tints in the foreshore bottom left, taking care to retain the light passages, where the sun catches the wet mud. I then let the whole job dry out, having got a complete covering in an initial wash.

When the painting is absolutely dry, I begin to overpaint in simple but well drawn washes the bridge and other structures that stand out against the light, working in the water their reflections at the same time, making the latter a little less dark in tone than the object reflected, softening off edges here and there. Finally, and with the strongest darks, I paint the foreground boats and shore and register the sharp darks of the stones, etc.

HARBOUR REFLECTIONS (FIG. 41)

As cast shadows indicate the contour of the surface upon which they fall, so reflections explain what is happening on the surface of water. When the surface is disturbed by a breeze and small wavelets appear, the dark reflections are interrupted and warped by bars of light reflected from the sky, each bar following the shape, size, and direction of the wave. When the movement is slight, as seen in a harbour on a calm day, reflections are just wobbly,

but their movement is difficult to follow. If you wish to observe just what happens at a given moment, concentrate on one particular feature, say a post. Close your eyes, then open and close them rapidly like a camera shutter and try to remember just what you saw of the reflection in that moment.

You will notice that those areas of water reflecting the light of the sky are just a little greyer than the sky itself, but in the dark reflection you not only have a suggestion of the colour of the object reflected but also the colour of the water, and, if near to you and clear, then you will see the colour and details of the bottom through the water. This is particularly apparent when you look against the light at a rowing boat floating in calm water a few yards away from you. Suppose the boat is painted deep blue; you are just conscious of the blueness in the reflection, but are more aware of the bright green of the water as the sunshine penetrates through it from the other side of the boat. This is seen in the reflection only, for the water elsewhere is just shimmering light.

If you are thinking of the colour of the object you will find that colour in its reflection (modified, of course). If the colour of the illuminated water itself, or the bed beneath attracts you, then you can see these colours, but you cannot see and think of all three together. This is where *you* come in and you will paint that colour which will best describe what you admire most. In the case of the boat, I should most certainly go for the light in the water.

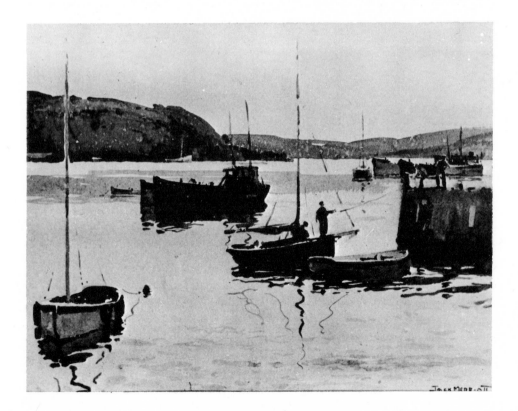

Fig. 41 Harbour reflections. *On arrival at the sketching location we make studies like this to absorb the atmosphere and work out the possibilities of the place.*

Rough Passage
This charcoal impression, prior to painting the picture, helps to a better understanding of the nature of the sea.

The Cove
The value of charcoal for these quick studies lies in the ease with which some degree of true tonal value can be achieved.

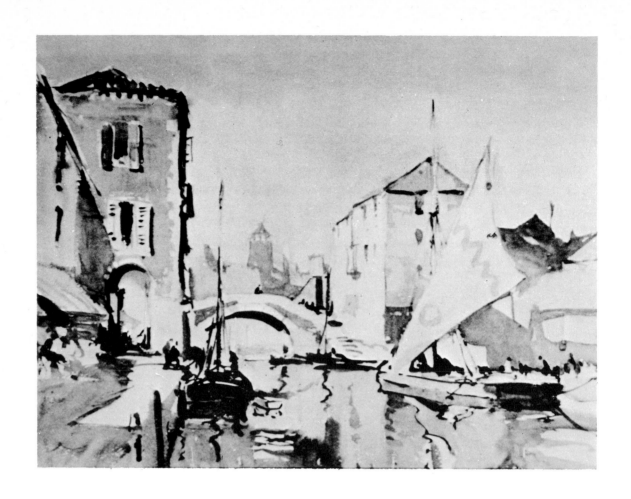

Reflections at Chioggia
*This loose and watery picture shows how to
handle reflections by using a controlled wash
method. At the start an all-over variegated wash
was applied and then wet stronger tones were
dropped in for the reflections. Final touches
were made after all was quite dry.*

Studio Workshop 8

INTERPRETING WATER AND REFLECTIONS

This is your final assignment of work arising out of this course on water-colour painting, and if you have worked consistently through these self-study sections you must be making progress. The more you observe, think, then paint, the more you will improve. You are bound to find many frustrating difficulties to wrestle with, but try and accept this as the exciting fun of it.

When things are not going well, give it a rest for a period. Don't keep working on one picture too long. It will never come right unless you refresh the mind with rest and change. When I am sketching from Nature, I make a start as soon as possible whilst my mind is fresh, and paint for about an hour. I then rest, smoke, have a cup of tea, look and walk around a little, and then return to my work with a fresh eye and added zest.

Just as we use the controlled wash, or wet into wet method, in our painting of sky effects, so we must industriously pursue this method in our interpretation of water, the mirror of the sky. At all times be on the look-out for water subjects that appeal to you, and try and translate them mentally into watercolour. Concentrate your thoughts upon the nature of the colour and tone that will form the initial wash or backing for the intended effect. Upon this, stronger tones in well drawn simple washes will be overlaid.

Make many studies of the reflections in water from direct observation, checking your tonal values by squinting at the subject. Remember that in general, the light objects reflected will appear to be darker, and dark objects lighter in the reflections. Both will be influenced by the natural colour of the water at the time.

Train your observation and memory by carefully watching the movement of water, so that you will be better able to portray its characteristics.

TEST-YOURSELF EXERCISES

1. Find a pool, reservoir, or any stretch of calm water where reflections of buildings and trees can be seen. Make watercolour studies of the water from differing viewpoints.

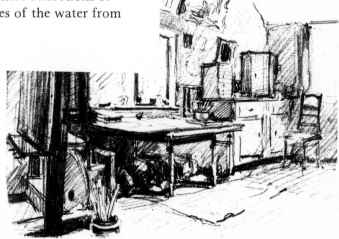

2. Make a serious attempt to tackle water in movement. This could be the same pool, with the water disturbed, or a flowing stream with rocks, posts or any other objects, in and by the water, so that the reflections are interrupted.

3. If you live near the sea, try out the effects of storm and wind upon the waves in the manner dealt with in this section.

4. Always take the opportunity in times of flood to go out and capture this effect.

5. Go out and find any subject that pleases you. Stand and look at it as long as you wish with the object of committing it to memory. Then go back home and paint it.

We are now being whisked away to accompany Jack Merriott on an imaginary painting tour. This serves to put into practice all the work previously done together, and shows how to make the most of such excursions.

A great deal of Jack Merriott's success as a teacher was due to the example he set with his tremendous enthusiasm, which in turn roused his pupils to greater effort. When he conducted group painting holidays, he would be up soon after dawn, and throw himself excitedly into whatever engaged his attention, infecting all around him. Ordinary mortals found it difficult to keep pace with him. There was never a time of day, condition of weather, place or situation, that was not, according to Jack, absolutely ideal for this effect or that method. Nothing put him off, or overcame his determination to work.

It is important the student understands that what follows now is a description of the working of Jack Merriott's mind, his thoughts and reactions when stimulated by the discovery of painting subjects, and of the various techniques he employs to portray them.

12 *Painting Holidays*

Two whole weeks to enjoy ourselves! What a happy thought and what an exciting period of anticipation for several weeks beforehand whilst we gradually accumulate all the paraphernalia, colours, brushes, pencils, sketchbooks, etc. As we place them in the most convenient receptacles, we are already sketching in our imagination, enjoying perfect weather and other conditions, with a ready-made subject spread before our admiring gaze, where the sun stands still, the tide never alters, and we sit alone and unmolested by orange-sucking children! We know that it will not be like that, but why not enjoy the thought?

SKETCHING AROUND POLPERRO HARBOUR

The first morning comes heralded by a primrose-coloured sun newly risen from the sea and shining in a grey-blue sky giving promise of a fair day. Let us slip out before breakfast to acclimatize ourselves to our surroundings. I take a sketchbook and fountain-pen, and we start off round the harbour to the village. I am glad we donned our coats as the morning breeze is a trifle

Fig. 42 Cottages at Polperro.

chilly. About 200 yards and we notice a delightful huddle of cottages, so typical of Cornwall, at the foot of a steep slope. We will walk a few yards up the hill so that the distant hills rise up behind the cottage roofs to make an interesting background. On the left is the entrance gate to the local chapel, and beyond this the baker's shop. Between this and the antique shop on the right is a narrow thoroughfare leading down in shady mystery to the stream, which is noisily rushing onwards to the harbour and its final extinction in the open sea.

I sit down on an old coping by the roadside and start a drawing in ink (Fig. 42). The sun is not high enough to cast any interesting shadows, so I am satisfied to register the main forms loosely, observing my eye-level and how the lines slope in perspective. I calculate that the sun, as it rises, will later be shining from the left, so that I could perhaps make a painting of this from my drawing in the studio if we have any wet weather, knowing now where the shadows will fall. I commit to memory the green paintwork in the bakery windows, the deep browns, blues and greens of the antique shop windows, with their suggestion of old pottery, brass and copper within, and the deeply recessed windows and doorways.

As I make a rough note of one or two figures, tiles, etc., I become aware of that delightful aroma of newly baked bread, and closing my book, I retrace my steps down hills, past chapel and baker's. As I pass the open cottage doorways abutting on the harbour, the smell of frying bacon assails the nostrils, a delectable reminder of breakfast and a cup of hot tea. We can chat over breakfast as to our future plans. The holiday is barely started but I already have one experience recorded which I intend to make use of before this is over.

I do not propose to start painting just yet, I want to build up a little more experience first, so after the meal I take a stroll "up-along," armed with the inseparable sketchbooks, and, a little exhausted by the steep climb to the cliff top, I decide to sit down on a most conveniently placed oak seat facing out to sea. As I feel the warmth of the sun on my skin I drink in the lovely view before me. I am on a rocky headland high above the harbour lying down to my left, and glancing down I see the white-faced cottages reflected in the green water, slow to awaken on this delightfully lethargic morning. At my feet the jagged rocks descend in the form of a promontory jutting out into the sea and giving protection to the harbour, and down below the deep blue and emerald sea, with its foamy breakers, contrasts with the gold, orange, green and brown of the seaweed and lichens which festoon the rocky crags. To my right, above dark caves, the hills rise still higher behind a row of rich dark conifers, monestial blue and burnt sienna, which provide a strong contrast with the fishermen's whitewashed hut immediately below them on the cliff path and cast their long shadows over the adjacent enclosure, which is yellow with freshly opened and dew-bedecked daffodils. I must make a drawing of this, and in turning on the seat I am aware of a metal plate set in the back, which is inscribed thus:

"In loving memory of Lieut. H. Wilfred Holt, R.E. aged 24. Killed in action at Mons, Aug. 23, 1914."

Here is food for thought. A young man in the prime of life with no particular quarrel perhaps with any specific individual, was thus suddenly deprived of all such pleasures of life as I was now enjoying. Surely I should be grateful for this memory, and for the fact that I have life, sight and a mind capable of appreciating the joys of natural beauty; I am reminded that every moment of life is precious and every minute of leisure far too valuable to be frittered away in boredom.

So I make another pen drawing (Fig. 43) of the view to my right, where the fishermen's hut is my centre of interest, the rocky cliff path leading to it and leading the mind round the back, over the clumps of yellow gorse to the deep-toned fir trees, stark against the sunlit hill-top beyond, and down through their shadows to come to rest amidst the peaceful glory of the daffodils. My drawing is far from detailed (the daffodils are mere dots and dashes) but is just a shorthand note guiding the mind as I have indicated. It will help to keep fresh in my memory just those details and characteristics which excited me during those moments of intense pleasure. Perhaps I shall paint that experience one day.

I now amble back to our temporary home, making a few notes here and there of a rowing boat at the foot of the rocks where a fisherman inspects his crabpots, two or three figures lounging on the quay, and so on, and arrive for lunch with a feeling of satisfaction that I have accomplished something, and that I have secured data which will serve for some hours of future pleasure when holidays are a memory.

Fig. 43 Pen sketch. *A fountain-pen filled with black ink makes a good drawing tool for collecting sketch material. Use a sketchbook containing thin smooth paper.*

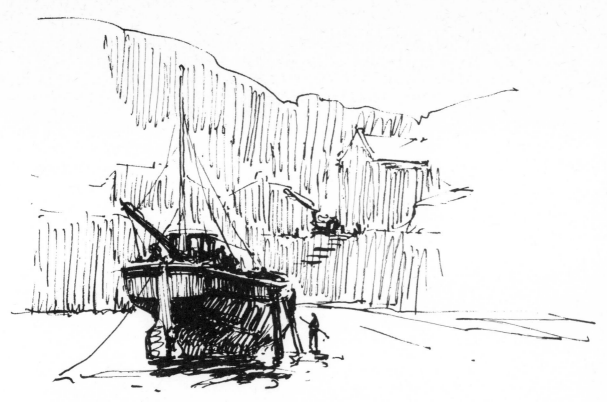

Fig. 44 Pen sketch. *The boat and men stand against the light. Use this design for a watercolour painted in the direct method. See below.*

A PAINTING FOR YOU IN THE DIRECT METHOD

I have had a pretty strenuous morning. I'll sit around the harbour this afternoon while you do the work. Try a watercolour. I see you have brought a minimum of materials, a half imperial sheet of paper and that you have a restricted palette of ultramarine blue, light red, yellow ochre, ivory black and viridian. Good! The tide is out and a pilchard boat is supported on its legs in the inner harbour, where two men are scraping the hull, one on a ladder and the other down near the keel (Fig. 44). I reckon we shall have about an hour and a half before the incoming tide interrupts them, and the light will remain fairly constant for that period since we are looking towards the sun. These are points we should always consider before starting work.

Because we are looking into the source of light the boat, ladder, men, buildings and hills on the other side of the harbour are thrown into an intriguing atmospheric silhouette except for where here and there the roofs reflect the rays of the lowering spring sun. The direct method is called for. Do you remember what that was? Yes, you will go for the boat and men right away without preamble, before they pack up and the tide comes in and spoils things. You are going to work on the dry white paper and must be careful to have your colour and tone strong enough.

With the No. 2 brush and a light wash of blue, light red or brown, you draw in the silhouette of the boat, ladder, legs and shadow in correct proportions, not too large, to the left of centre in your paper, with the man up the ladder and the other at the keel. Any mistakes can easily be washed out with clean water and a larger brush. Next you draw a line where the shadow at the base of the quay and buildings on the other side of the harbour cuts sharply against the brilliant light reflected from the wet mud, noting where this cuts through the boat, and then the outline of the distant hills against the sky.

Now mix the colour of the boat. What is it? Do you approach near to see whether the boat is painted green or blue? What does that matter? The point is, what is that atmospheric colour of a boat seen in silhouette against strong sunshine? I should probably mix ultramarine blue, light red, and a little black. Now blot it in strongly as one big blot, just allowing for any small specks of light on the deck or wheelhouse, or on a man's cap seen against the dark hull. That looks much too dark I know, but you'll probably find it right when you have painted in all the other tones. Be careful that your drawing is right before you start your wash, as it cannot be satisfactorily altered afterwards. If there are any obvious alterations in tone, such as a wide white line around the hull or reflected light underneath, do not cut up the silhouette by leaving these white, but carefully take them out with a semi-dry brush just before the wash dries. This will then be just noticeable, with softened edges, and not so obvious that the unity of the silhouette is destroyed. I'll make a quick sketch to give you my impression of the effect (Fig. 44).

Now add some water to the wash, and a little yellow ochre, and paint in the silhouette of the background in one wash, varying slightly in colour and tone to suggest a difference between grass fields, trees and buildings, but retaining the unity of one wash, and bring this down sharply to the brightly lit deck and superstructure of the boat, which should be left as white paper, and down to the extent of the shadow of the quayside on the mud. When it is nearly dry, wipe out the mast with a damp brush as before, and when quite dry mix a wash of light red and yellow ochre and wash in the sky, adding a little black as you approach the distant landscape, to neutralize the colour somewhat. With a wash of the same colours but slightly deeper in tone, paint in the mud behind the boat. Warm it up with light red as you work through to the foreground, leaving suitable spaces here and there near the hull to suggest puddles, reflecting the sky.

You have now painted this scene in three simple washes, each varying in tone and colour to obtain the maximum expression in each. The final phase will be to touch in with yellow ochre the sunlit deck and edge of the quay, a little warm grey for the puddles (slightly darker than the sky they are reflecting), and the mast and reflections under the hull, and then to add a few darker touches to indicate the form of a particular building or wall here and there in the background. These must be very delicate not to cut up the original wash. A few stronger and richer darks may be added in the foreground, especially close up to the puddles to bring up the light, and under the keel,

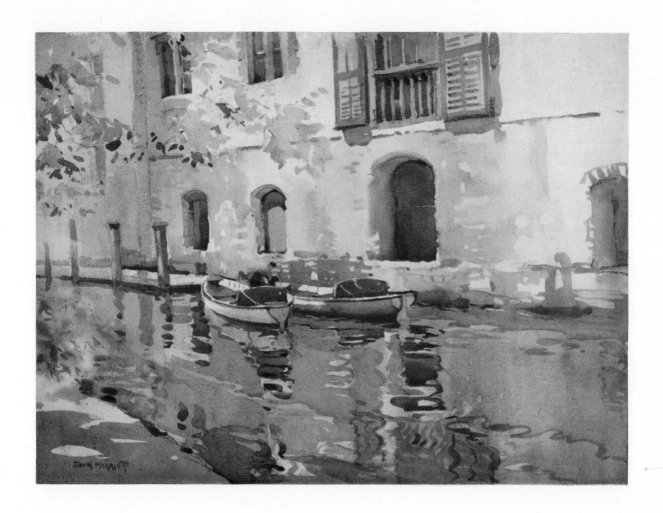

THE CANAL, BRUGES
Watercolour 15 × 22 in.

*This was a demonstration for one of our holiday
painting groups in this medieval town in Belgium.
The lesson concentrated on the way to paint
reflections in water. As usual the first step was to
establish an atmospheric backing of light tone and
tint, into which some of the darker local colours
were put while all was wet. Accurate judgement
of the relationship of the tone values of reflections
and objects causing them is of vital importance.
The lights are reflected darker, and the darks in
objects will be lighter in their reflections.*

Plate XV

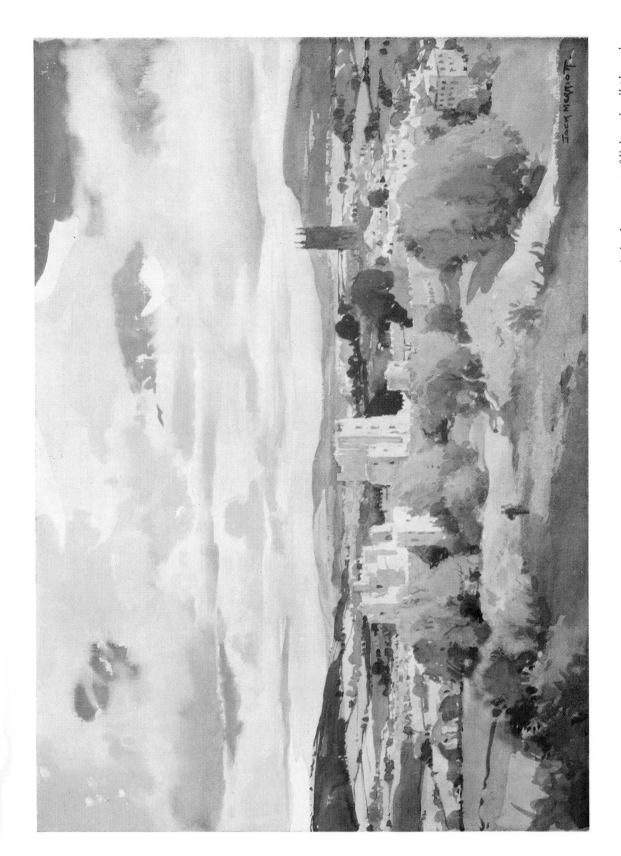

LUDLOW
Watercolour 15 × 22 in.

Plate XVI

A simple statement of light and well planned
passages of darker tones, caused by cloud
shadows, etc., is the way to tackle a panoramic
view. (Chapter 12.)

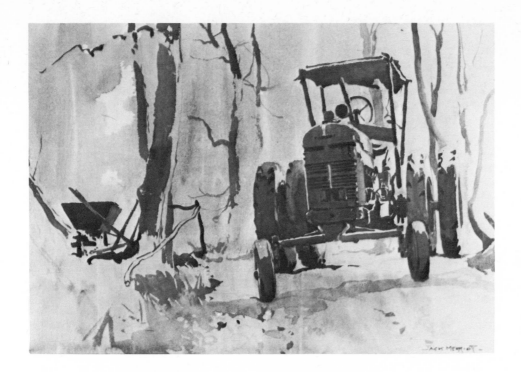

watching the edges all the time. Each dark touch will represent some object,
e.g. a boulder, coil of rope, anchor, etc., which obstructs the light. The edge
will therefore be soft at the top where the light filters over, and sharper at
the bottom, at the edge of cast shadows. Just a suggestion of green will indi-
cate the windows of the wheelhouse with the light shining through.

SUPERIMPOSING WASHES

If your washes have been judged correctly in tone and colour variation and
cleanly applied without too much over-painting, you should have a satis-
factory sketch. Remember the first washes should be as accurate as possible
to the general tone of the passages represented. This being so, there should
be no need to cover the whole wash again. Additional washes applied over
part of the original wash to explain buildings, trees, etc., should, if possible,
be composed, at least in part, of the same constituent pigments as the under-
painting. After this, one or two further washes may be safely applied, provi-
ding parts of each under-painting are left uncovered. These will then still
remain pure and clean. The impression is thus conveyed that each wash was
applied and left as intended in the build-up of tones. If complete washes are
covered, on the other hand, it is obvious at once that the original strength
was underestimated, besides robbing the picture of light and purity and
tending to a dirty result.

RETAINING THE "FRESH" LOOK OF WATERCOLOUR

Many amateurs superimpose too many washes, of ill-judged tone and tint, which results in a dirty appearance to the finished painting. To retain the clean, fresh look is a matter of keeping the work clean and avoiding the application of too many wash layers, which create dirt.

Careless mixtures of paint will give the muddy effect, such as ultramarine blue and burnt sienna, applied to a wash of yellow ochre when nearly dry. Starring out at the edges will certainly ruin the effect, as the uneven drying causes the accumulation of particles of these two colours to make a hard, uneven and dirty line along the border of the slowest drying area. You will learn by hard experience the bad mixtures of colour creating dirt. When applying additional washes, the underwash must either be quite wet (controlled wash method), or quite dry. The halfway mark is always dangerous.

Keep your palette clean. There is a difference between a palette covered all over with clean colours, mixing together in a clean limpid way, and a palette covered with dirty colour including blacks, brown, cigarette ash and sand! I invariably work with the former, starting with a perfectly clean palette which is very soon dripping with colour.

A smudged drawing in pencil or charcoal underneath, and a number of rubbings-out disturbing the paper surface, can cause dirt, as can careless scrubbing-out.

AN OBSERVATIONAL EXERCISE

We will not unduly tire ourselves on the first day, but take a quiet evening walk along to the cottages we saw this morning. We now see them under very different conditions, by moonlight. Can we remember this effect? The direction of the moonbeams; the warmer darks of the distant hills compared with the cold light on the slate roofs and shaded sides of the white buildings; the yellowish light on the white walls and roadway, and the general simplification of the shadows and distance. I wonder how long we can retain this effect, for the light is not strong enough to paint it on the spot.

MOONLIT COTTAGE

The next day having set in wet, we might make an attempt at a memory sketch of those cottages we saw last night by moonlight, with the aid of the drawing (Fig. 42), we made yesterday morning. After drawing in the subject with ultramarine blue as usual, I wash in sky and background down as far as the roofs and chimney stacks with yellow ochre and light red. When this has sunk in somewhat but is still wet, I continue the wash over the roofs with ultramarine blue, changing again to yellow ochre and black for the moonlit side of the antique shop and greying off on the shaded side of this and the

Fig. 45 Moonlit cottages.

other buildings seen in shade, and continuing the wash to the bottom of the
paper with yellow ochre and French ultramarine blue for the light on the road.
When all is dry I wash thinly over the sky with French ultramarine blue and
light red and continue the same wash with a much stronger mixture of the
same colours for the hills, stopping this wash sharply at the roof tops and
chimneys; one or two small spaces of under-painting are left to suggest dis-
tant roofs. I next add further blue-grey tone to the shaded areas of roofs and
walls, and strengthen it for the darker cottage seen through the narrow open-
ing, watching the slant of the light roadway at the foot, also the cast shadows
under the eves of chimney stacks and building in the foreground. Finally,
details such as windows, chimneys, slates and figures are added, and one or
two real darks, such as church porch, doorways and so on, complete the
sketch (Fig. 45).

Come on my magic carpet and be transported to the delightful city of Bruges in Belgium. We arrive on a Saturday morning and another sunny day. We go to the market square where the grand old belfry, of such noble proportions, looks down upon a scene of intense activity, for it is market day. If we ascend the steps of the Town Hall we shall get a general view, and can admire the different types of buildings which surround the square, the step gabling, and many kinds of windows each as different in colour from its neighbour as are the brightly coloured awnings over the many stalls. In the shade of a huge umbrella, I see an appetizing display of dairy produce, a rich red stack of Dutch cheeses, massive blocks of yellow butter, eggs and bacon — I can just get the delightful smell from where I am. Under another umbrella are draped festoons of lace and coloured ribbons. Below me are crates containing chickens, cats and rabbits, and there are cages of white rats and mice, and bowls of goldfish, besides many mysterious glass tanks which probably contain snakes and lizards. To my left I see three or four horses and carriages of a ripe old vintage, and everywhere the people are crowding and jostling around, farmers, priests, Dutch men and women in national costume, foreigners on holiday, butchers, bakers, and candlestick makers.

Impossible to sit down and sketch this in colour, but we can make a drawing and note the different colours. If I were painting this on the spot I should feel impelled to make a drawing first in case I missed anything which I wanted. I would then go straight for the shadows, those under the awnings in front of the cafés, where I can just discern people lounging at their tables on the pavement, sipping their "cafés-filtres." Then there are the shadows under the awnings of the stalls and I would indicate how these shadows show up the dark silhouettes of figures, piles of fruit and merchandise, and in contrast the light silhouettes of other figures cutting into these shadows, thus explaining the objects in shade and those in sunshine. A complicated subject, but well worth attempting.

In the evening we can sit at one of those tables outside a café. What a wonderful sense of the mediaeval hangs over that old belfry, which is now seen dark against the sky. Some of the windows are lit with a faint orange glow. Next moment the silhouette is reversed, when obscure lights illumine the top of the tower with an emerald green radiance, bright against the deep purple-blue of the sky. Weird long blue shadows are cast over the stonework and lower down warmer lights show up the brown and sienna colouring of this ancient edifice. The great square is now empty except for the people patronizing the cafés, and we can sit quietly sketching by the aid of the café lights, a nocturne we shall ever remember, made perfect by the sound of the carillon, playing an old familiar tune in deep vibrant notes, so clear and yet so remote.

My watercolour reproduced on Plate XV was a demonstration sketch painted on the spot for a group my good friend Ernest Savage and I took

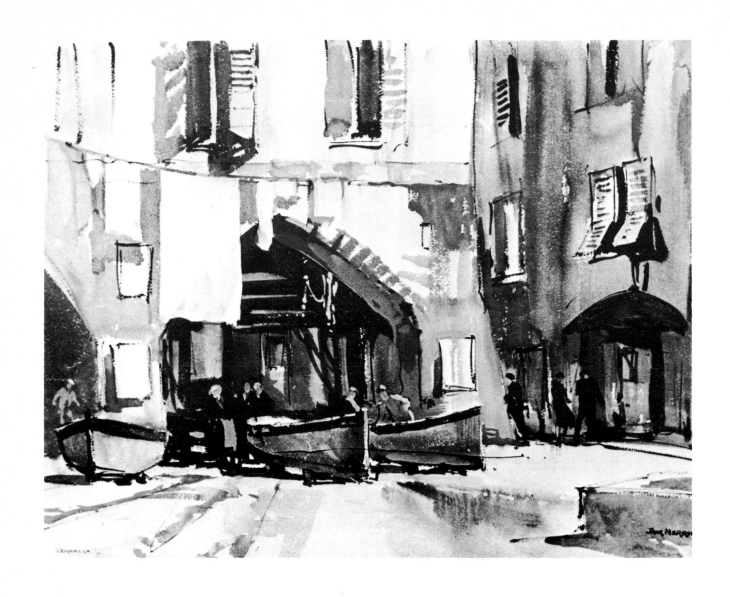

Village in the Cinque Terre
We had just had breakfast together in the café to the right when our group arrived for their morning demonstration. Jack Merriott chose this simple composition and painted with exuberance. It was a full sheet, 30 x 22 in., and the painting was completed in ninety minutes.

Haymaking in Austria
This picture clearly demonstrates the importance of well-drawn washes, of various tone values that give an air of simplicity to the painting. It shows an apparent ease of approach but a great deal of planning is required before a picture like this is painted.

for a sketching holiday in Bruges. This lovely city is full of subjects for the painter, and a perfect place to collect an abundance of sketch material for later pictures. Understandably, the amateur artist likes to take some finished paintings home from such a trip, but I am convinced that the majority do not attach sufficient importance to the sketchbook and the need for many quick notes made in pencil, ink, or charcoal, of places, people, animals, and things of all descriptions closely associated with experiences on painting holidays. From this kind of sketch note, the emotion of the moment and the scene can be recalled to the memory, to assist us to paint pictures on our return, during the winter months.

Perhaps it would be as well if we considered this aspect of holiday sketching, and I tell you something of my method for using sketch notes for pictures. For this we will fly back to Ludlow.

PAINTING FROM SKETCH NOTES

Before returning home, after conducting a course at Ludlow, I decided after an early breakfast to climb the hills at the back of the hotel, and have a quick look at the castle from above. It was a windless morning and, the sun shone brilliantly between masses of soft, luminous cumulus clouds.

Fig. 46 Landscapes from sketch notes.

After the painting course it was a relief to be alone in a big open space where I could look down upon the whole town with its castle washed clean by wind and rain to a creamy white, and the varied tints of the fields stretching away to the blue and purple distant hills. It was then I noticed the changing beauty due to the movement of cloud shadows over the contours of the landscape.

I felt I must make a quick note of this, and you will see from my felt-pen sketch that I selected the instant in time when the castle was receiving full sunlight, contrasting with the deep shadows on the trees, church and part of the town.

My rough note took about fifteen minutes, during which I did my best to memorize the lighting effect and colours. You will see where I have included colour notes to aid my memory, and with simple line hatching have described something of the tonal differences in the landscape (Fig. 46).

OVERLOOKING LUDLOW

Back in the studio some days later, I decided to paint the picture whilst the impression was still fresh in my mind (see Plate XVI). Taking a half imperial sheet of Bockingford paper 140 lb. I sketched in the design with a weak mixture of ultramarine blue and water. Feeling I must get into the paper atmospherically, as it were, I applied a wash over the whole sheet, changing it in colour and tone to represent approximately the average light in each part of the scene. Yellow ochre and light red were used for the clouds, ultramarine blue and light red for the blue of the sky, and darker part of the clouds, alizarin crimson being added to this mix for distant hills, changing to yellow ochre, and viridian for fields and foreground, and pale raw umber for the castle. These colours all blended together in the one overall wash.

When this wash was dry, I painted the shadowed trees, church tower and middle distance behind the castle in full strength, leaving the castle as a light silhouette, and then went for the other more distant cloud shadows. This registered my main lighting effect.

Then I proceeded to put in the middle tones of trees, buildings, castle walls in shade, and cloud bases, carefully judging the relative tone values to express form and leaving the original wash to represent the lights. The final touches gave a suggestion of detail, such as house shapes, windows and the figures.

If you have not attempted this form of translation before you will not find it easy. But you must take steps to train your memory with constant sketching. Then, merely by the aid of your notes, try making a watercolour from the best of your holiday sketch notes.

I should like to have dwelt longer on many other excursions, and taken you in imagination to other attractive spots, to Scotland, Ireland, France, and Italy, but lack of space forbids. However, I cannot conclude this itinerary

without dropping in to a particular favourite spot of mine, a beechwood near Arundel in Sussex, and whilst you look on, I will paint it for you.

THE BEECHWOOD

There is a feeling of the soft atmosphere of spring as we drive together towards Arundel, where by the roadside bordering the Duke of Norfolk's estate is a magnificent woodland of mature beech trees that rise in stately fashion from the warm brown, peaty earth. We will park our cars on the opposite verge, well off the road, then you can follow me into the wood,

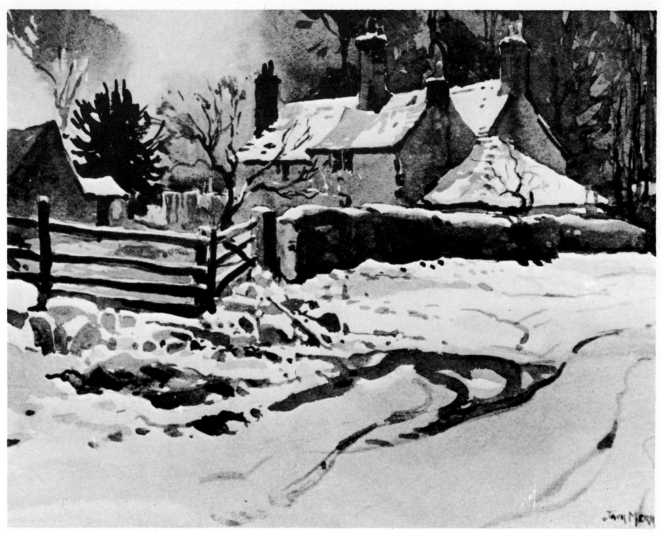

Watercolour in Winter

and I will talk to you about tree painting, and will show you how I painted
the full imperial picture that you will find reproduced in colour on Plate XIII.

I have always been attracted by the beauty of trees of every kind, and
have sketched them in every season of the year. In fact, it was a winter study
of elm trees painted in oils that was one of the first of my pictures to be
accepted by the Royal Academy. You will see from the numerous tree
sketches throughout this book the importance I attach to the constant study
of tree forms in order to portray their individual characteristics. I recommend
that you too make full use of your sketchbook to make careful drawings of
tree subjects from observation.

As we approach the beech tree group away from the road, we catch

glimpses of the distant hills, which are of a blue-purple tint, contrasting with the bright spring greens of the fields. I make a mental note not to make too much of this yellow-green in the distance, or all feeling of recession in the picture will be lost. Now I look for a vantage point for my composition, and make several quick sketches with soft graphite pencil, placing the main tree in various positions until I am quite satisfied with the arrangement and lighting.

Having decided on the design, I select a full imperial sheet of best-quality 200 lb watercolour paper, fix this to the drawing board, and place it securely on the easel. Normally I do not paint as large as this for outdoor work, mainly contenting myself with a half or even a quarter sheet. But this is a special occasion, a windless spring morning, and I am anxious to interpret the lighting effect with my usual broad washes. To do this quickly I must use the shaving brush. You could use any large brush, but over the years I have become accustomed to the shaving brush and have developed the knack of pinching the hairs together, forming a wedge shape, so that I can dig the tip into the colour required, without the hairs wandering into other pigments and thus contaminating my wash mixture.

Now for the layout of the design. Taking a No. 8 finely pointed sable, and with a weak mixture of ultramarine blue and water, I draw in the composition, starting with the nearest tree, placing it a little to the right of centre. I take

care to describe the true growth of this tree, reserving the blue line for those parts of trunk and branches that are in shade, leaving untouched those parts catching the light. As I work, I notice the play of branch shadows that fall over the bole of this beech, and put them in as you will see, over the lit area, for this helps to describe the rounded form of this smooth mossy green trunk. Then I indicate the growth of the other trees, watching the spacing of their trunks as they appear in the picture area, varying the distances between them to suit my design. This reminds me to tell you always to avoid having half a tree trunk running up the sides of your pictures. Always contrive to show both sides of the trunk, as I have done for the tree to the immediate right.

The design completed, I pause awhile, further to contemplate the lighting effect I want to achieve. The warm sunshine seems to pass almost diagonally into the picture from the right. I shall go for this, and mix up a large wash of yellow ochre, and with my shaving brush work the wash quickly into the paper with strokes following this direction, and beginning top right. Whilst this is wet I float in a little ultramarine blue mixed with black at the top to suggest a little remote blue sky above the misty clouds. Then making a somewhat stronger wash of the same colours, adding some light red, I give some indication of the soft twiggery at the tree-tops taking care to control this from running not too far into the sky washes. Quickly and while all is still

These sketches, left and below, were made with pen and brush with Indian ink.

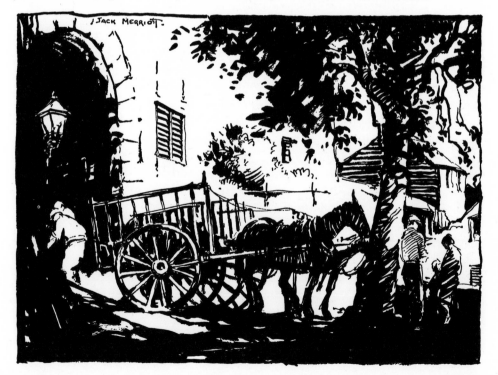

wet, I put in the blue-purple hills and a suggestion of distant fields, until I can work across the foreground boldly with more yellow ochre and light red, touching in some green for bushes and for the grass to the right. With a squeezed-out, damp No. 8 brush, I next lift out the main light areas on tree trunks and branches, pressing the brush into the paper to do so.

My first wash is finished, the paper is covered, and I have set up the light tone values in the tints required. This will give me the soft atmospheric backing I need for the more detailed and carefully drawn washes that are to follow.

The initial painting of a large picture tends to drain the artist's vitality more than he thinks possible, so while my wash is drying I take a little walk to stretch my legs, and after a smoke come back to my work refreshed and eager for the next foray with paint. Approaching the easel, I squint at my work through half-closed eyes, and then at the subject, in order to consider what adjustments of tone values have to be made. I start again, having decided to strengthen the distant hills and pastures, and to give a more tonal credibility to the middle-distance trees.

I begin work on the hills by damping the sky area above them with pure water, so that when the stronger wash of a similar tint is applied to the hills, the atmospheric edge to them will be retained. Mixing a wash of viridian and raw umber, I begin to paint into the wet purple-grey of the hills the effect of distant trees, etc., varying the tint of this middle distance area by the addition of yellow ochre. With a purple-grey, made with ultramarine blue and light red, I do a little more work to the tree-tops here, softening off the edges with a clean moist brush. Into this, whilst damp, I begin to describe the branch and trunk structure with stronger colour which helps to push the distance further back. Now I paint the trunk and branches of the main tree in full strength, using most of the colours in my palette: rich greens for the weathered trunk, browns and blues for upper branches seen dark against the sky, and a deep cool green for the holly bushes to the left.

I want to keep the foreground as a simple statement of flat, uneven ground covered with dead leaves and the remnants from winter gales. So with well planned washes (ultramarine blue and light red) a simple tracery of cast shadows is put in following the contour of the earth. Into this the rich brown leaf-mould at the base of the tree is brushed over, with a drag-like motion to leave speckles of light catching dead twigs and so forth.

I make a special effort to paint the darks into the tree behind the main beech, leaving the light paper where a branch reaches out towards me and catches the light. At this point, I leave it unfinished, let it dry and pack it up for the return journey, for I like to resist overdoing so-called final touches, until I have looked at my picture for some days under a mount.

As I shoulder my bag and pick up the easel I sing a gay tune, for I have recorded in my sketch at least something of the joy of that moment with Nature — just another treasured part of my life, and I am the happier for it. As I make my way back to my studio along the sunlit lane, the primroses,

bluebells and campion, the stitchwort and wild parsley in the hedgerow seem never to have been more lovely, and the blackbird and thrush join in my song, whilst the lark sings his song overhead.

This is indeed a beautiful world. What need is there for shouting "I have painted a picture — come and see it"? What necessity for public appraisal or critics' approval? My picture may be destined never to be seen by anybody but myself. It is done and I have added something to my life which nobody can take from me.

I hope that our excursion together has helped you with many ideas as to what to look for, how to master a few more difficulties, and how to get the greatest pleasure out of your painting in watercolour.

It may interest the reader to know that, like so many of Jack Merriott's pictures, "The Beech Wood" eventually found its way into a public collection. It can be seen in the permanent collection of the Brighton Art Gallery.

Now that you have read this book and have heard the voice of this master of watercolour, it is likely that you have been impressed with his sincere attitude towards the beauty of Nature and his constant striving to express pictorially her infinite variety. Despite his success as a painter, and his popularity as a tutor, he remained an unaffected, simple man with a generous nature. He set a fine example with his constant endeavour and sheer hard work. Many would say that he worked too hard, but painting was his life and he made it his pleasure. In so doing he brought enjoyment to many.

I hope you too have enjoyed sharing his experiences and will be encouraged by his teaching to progress with your own painting. (Ernest Savage.)

Stile in the Hedgerow.

Index